T0208576

Bertolt Brecht WAR PRIMER

Bertolt Brecht

WAR PRIMER

Translated and edited with an afterword and notes by John Willett

VERSO
London • New York

This edition published by Verso 2017
English-language edition first published by Libris 1998
Originally published in German as *Kriegsfibel* by Eulenspiegel Verlag 1955
Translation © Stefan S. Brecht 1998, 2017
Afterword, notes and chronology © John Willett 1998, 2017

1 3 5 7 9 10 8 6 4 2

Verso
UK: 6 Meard Street, London W1F 0EG
US: 388 Atlantic Ave, Brooklyn, NY 11217
versobooks.com

Verso is the imprint of New Left Books

ISBN-13: 978-1-78478-208-5
ISBN-13: 978-1-78478-209-2 (UK EBK)
ISBN-13: 978-1-78478-210-8 (US EBK)

British Library Cataloguing in Publication Data
A catalogue record for this book is available from the British Library

Library of Congress Cataloging-in-Publication Data
A catalog record for this book is available from the Library of Congress

Typeset by MJ&N Gavan, Truro, Cornwall
Printed in the United States

WAR PRIMER

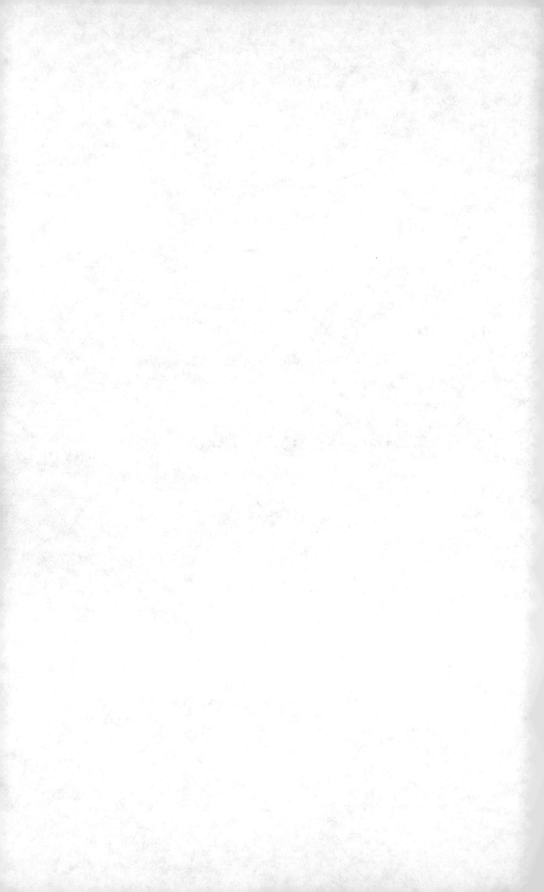

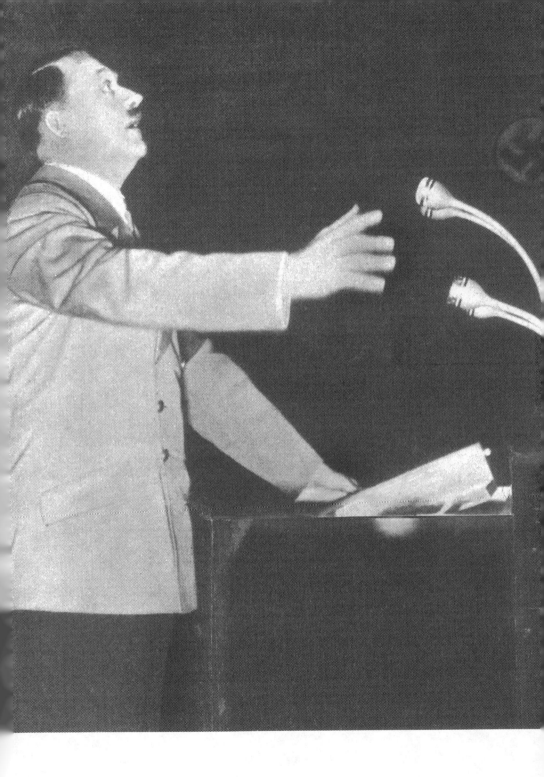

Like one who dreams the road ahead is steep
I know the way Fate has prescribed for us
That narrow way towards a precipice.
Just follow. I can find it in my sleep.

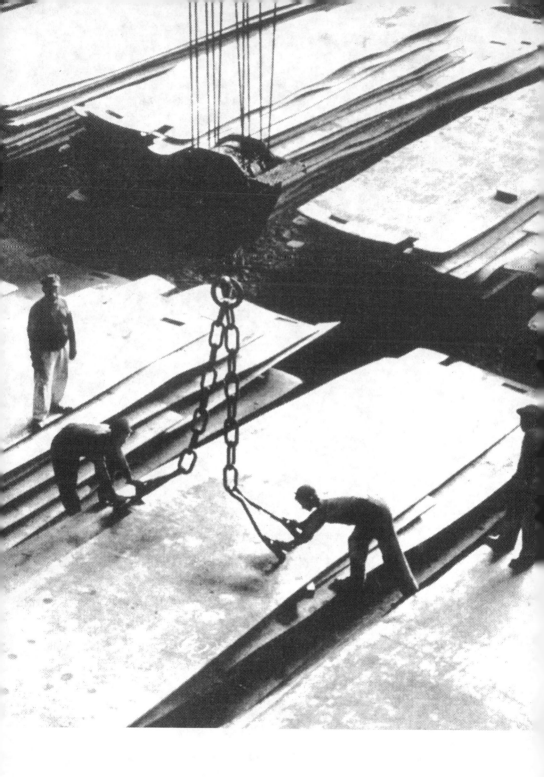

'What's that you're making, brothers?' 'Iron waggons.'
'And what about those great steel plates you're lifting?'
'They're for the guns that blast the iron to pieces.'
'And what's it all for, brothers?' 'It's our living.'

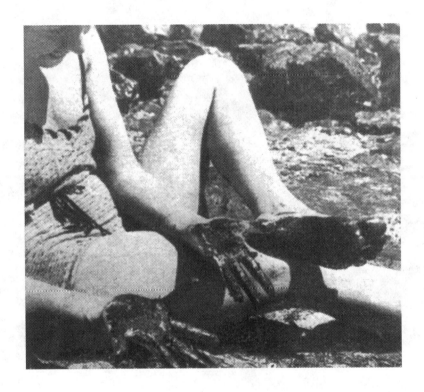

Women are bathing on the Spanish coast.
They climb up from the seashore to the cliffs
And often find black oil on arm and breast:
The only traces left of sunken ships.

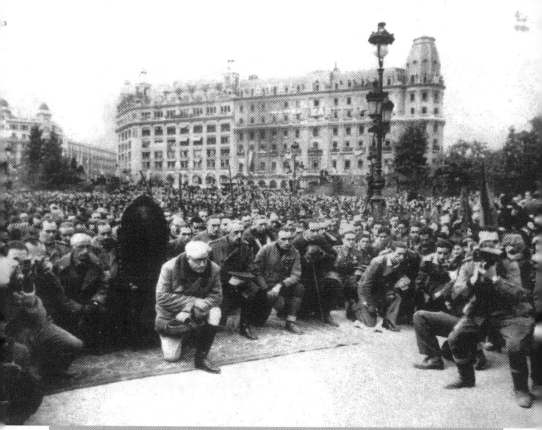

The conqueror, General Juan Yagüe, kneels before his throne–chair at an open-air mass in Barcelona's Plaza de Catalunya. In background is the Hotel Colon, whose tower is seen again in the picture below, at lower right. Behind Yagüe are Generals Martin Alonso, Barrón, Vega. Yagüe and Solchaga moved off to chase Loyalists to the border.

The bells are pealing and the guns saluting.
Now thank we God who told us to enlist
And gave us rifles to be used for shooting.
The mob is vulgar. God is a Fascist.

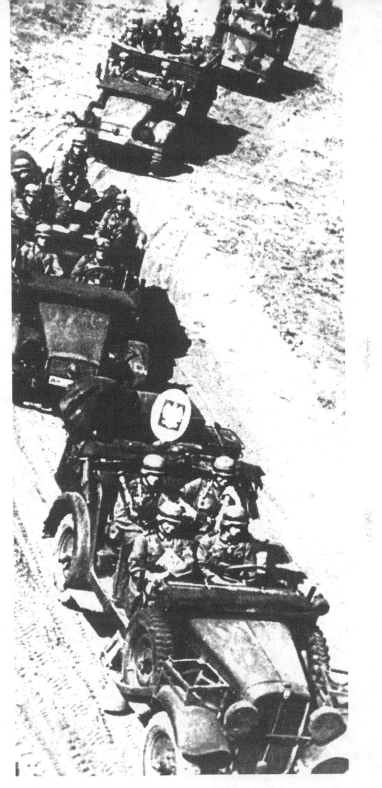

Suppose you hear someone proclaim that he
Invaded and destroyed a mighty state
In eighteen days, ask what became of me:
For I was there, and lasted only eight.

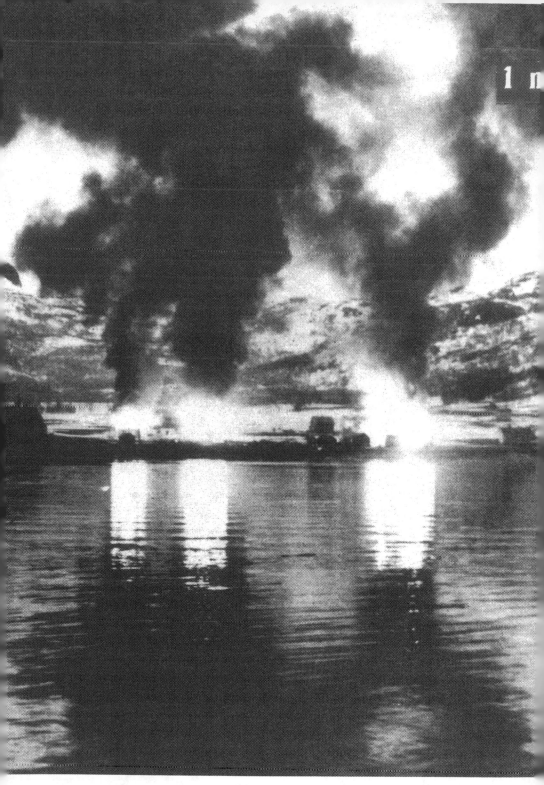

Great fires are blazing in the Arctic regions
In lonely fjords the clamour's at its height.
'Say, fishermen: who launched those deadly legions?'
'Our great Protector, protected by the night.'

Eight thousand strong we lie in the Skagerrak.
Packed into cattleboats we crossed the sea.
Fisherman, when fish have filled your net
Remember us, and let just one swim free.

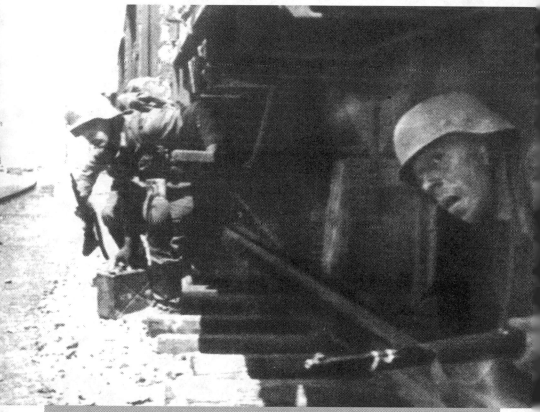

German assault troops, here emerging from beneath railroad cars to attack the Albert Canal line, were young, tough and disciplined. In all, there were 240 divisions of them. But despite the world's idea that the conquest was merely by planes and tanks, it actually depended on the old-fashioned tactic of a superior mass of firepower at the decisive point.

Before you join the great assault I see
You peer around to spot the enemy.
Was that the French? Or your own sergeant who
Was lurking there to keep his eye on you?

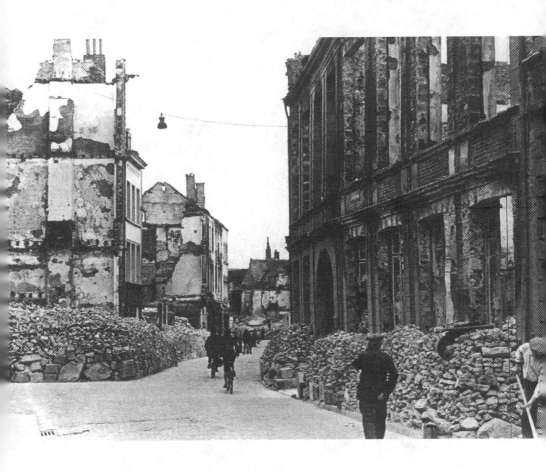

Unblock the streets to clear the invader's way!
This city's dead, there's nothing left to loot.
There's never been such order in Roubaix.
Now order reigns. Its reign is absolute.

May he die like a dog. That's my last wish.
He was the archenemy. Believe me, I speak true.
And I am free to speak: where I am now
Only the Loire and one lone cricket know.

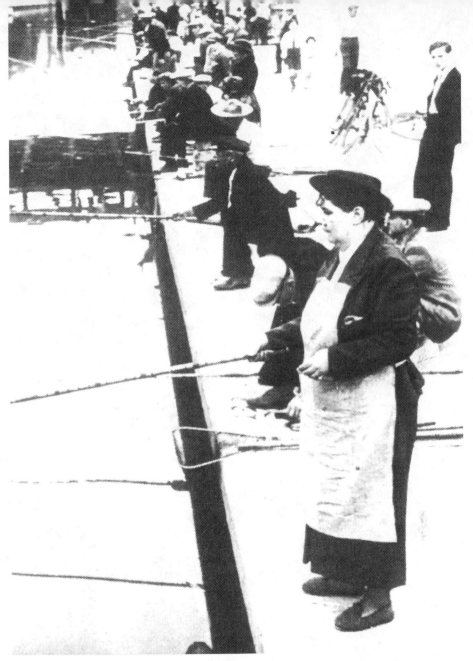

Våren har redan anlänt till Paris och här ovan ses ett av de mest typiska vårtecknen, fisket från kajerna vid Seinen har kommit i gång på allvar — och i år är fiskarnas antal kanske större än någonsin, står i direkt proportion till matbristen.

Spring has come to Paris. Here we see one of its most typical signs – fishing along the quays of the Seine has begun in earnest. This year there are more fishermen than ever – a direct sign of the food shortage.

Here in the heart of Paris you can see us
Trying to outwit a sneaky little fish
From which we hope to make a meagre dish –
Victims of Hitler and of our own leaders.

11

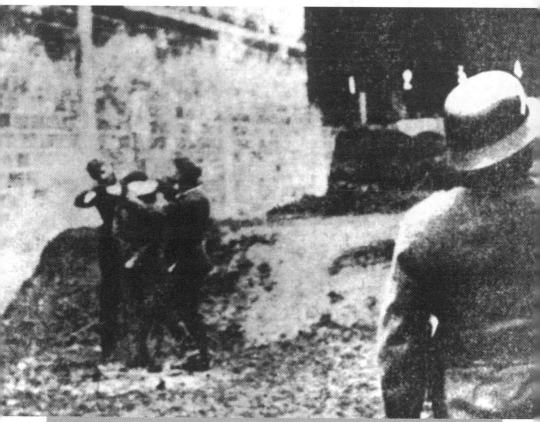

The Germans were 'kind' to this Frenchman. They blindfolded him before he was shot.

And so we put him up against a wall:
A mother's son, a man like we had been
And shot him dead. And then to show you all
What came of him, we photographed the scene.

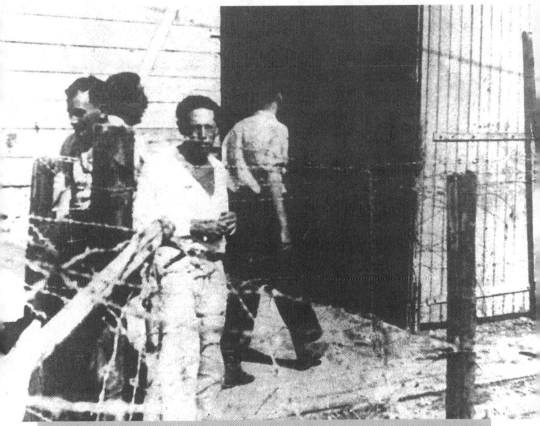

Lion Feuchtwanger (facing camera) behind the barbed wire in the brickyard concentration camp. This hitherto unpublished picture was smuggled out of France by Mr. Feuchtwanger.

It's true he was their enemy's enemy
Yet one thing they could not forgive: that he
Was enemy to his own government.
Lock up the rebel. Throw away the key.

13

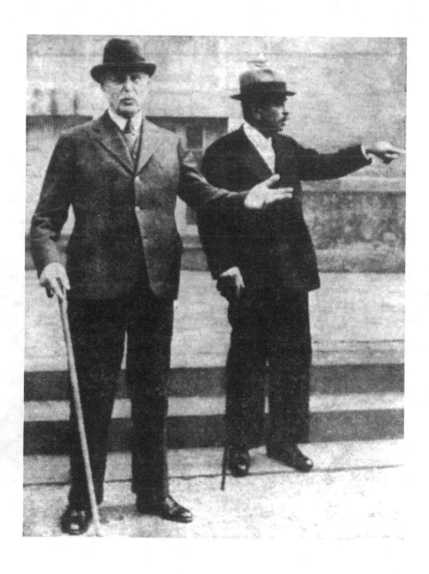

The people hate them more than a foreign foe.
Shitting themselves, they balance on the fence
And fear Germany less than they fear the French.
Be ruled by Germans? Yes. Ruled by the people? No.

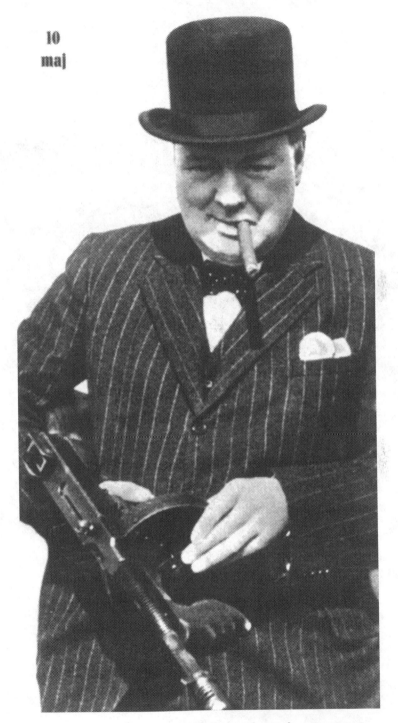

Gang law is something I can understand.
With man-eaters I've excellent relations.
I've had the killers feeding from my hand.
I am the man to save civilization.

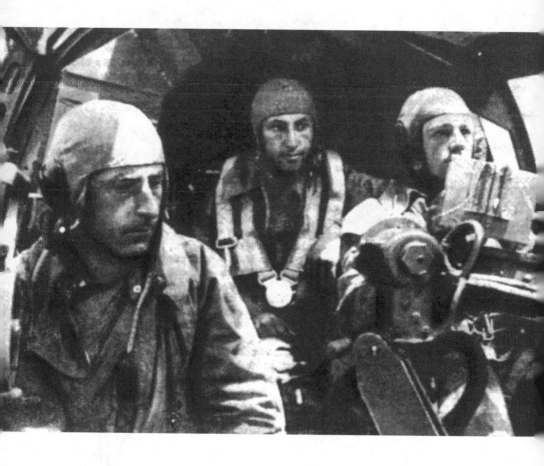

It's we who fly above your city, woman
Now trembling for your children. From up here
We've fixed our sights on you and them as targets.
If you ask why, the answer is: from fear.

City av i dag

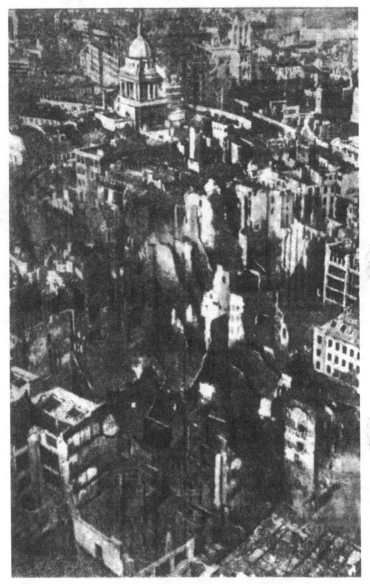

De centrala delarna av London ha under luftkrigets förlopp i mycket antagit karaktären av ruinkvarter. Denna vy över City är tagen från St Pauls-katedralen.

The City Today

During the blitz the City of London was reduced to a ruin. This view was taken from St Paul's.

> Here's how I look. Some men betrayed their duty
> And flew a course that differed from the map.
> Hoping to act as fence, I was the booty.
> Let's call my fate a technical mishap.

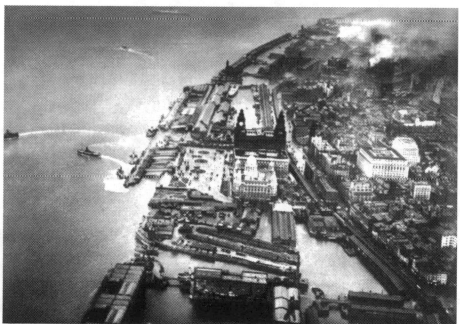

Liverpool harbour, England's second biggest, is well known to be the target of many German aerial bombardments and took many direct hits. This photograph gives a clear picture of the harbour – the smoke at the top shows that it has just been visited by German bombers.

I am a city still, but soon I shan't be –
Where generations used to live and die
Before those deadly birds flew in to haunt me:
One thousand years to build. A fortnight to destroy.

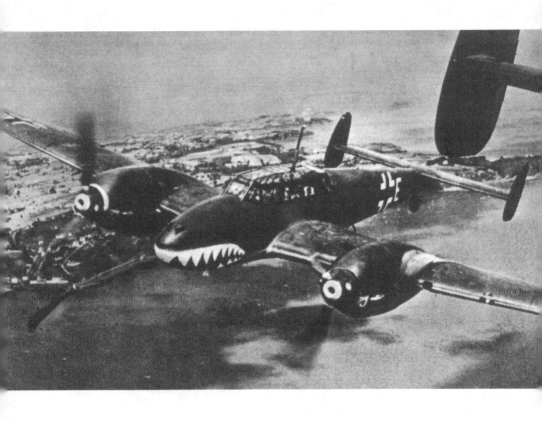

The 'flying sharks': that was the name we boasted.
Along the crowded coastlines we went flying
With sharks' teeth painted on our fighter-bombers
All of us sure for once that we weren't lying.

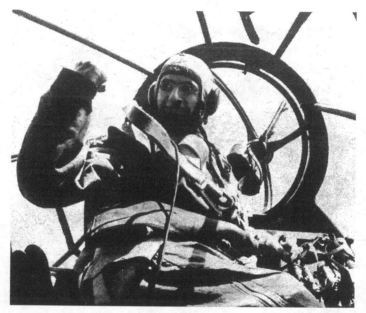

„Die hat hingehauen!" Der Beobachter, der soeben die Abwurfvor-
richtung ausgelöst hat, freut sich über den Erfolg seiner Bombenreihe

'Bombs Away!' shouts the observer as he celebrates a successful drop.

You're looking at a bastard, and a poor one!
'I laugh at news of other men's distress.
A corset salesman formerly, from Nürnberg
A dealer now in death and wretchedness.'

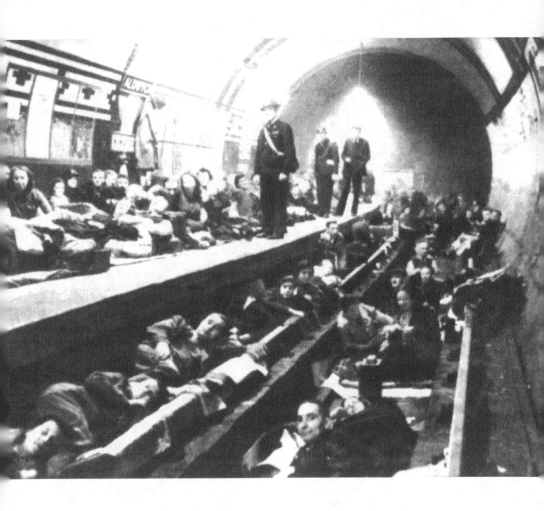

There was a time of underneath and over
When mankind was master of the air. And so
While some were flying high, the rest took cover
Which didn't stop them dying down below.

Ny födkrok

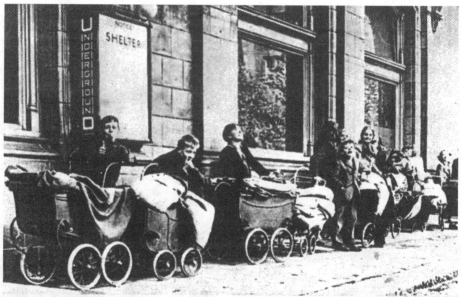

De fattiga i London ha genom bombräderna fått en ny födkrok. Ungdomar av båda könen samlas kring nedgångarna till den underjordiska järnvägens stationer — som bekant anlitade som skyddsrum under bombardemangen. Dels ha de „hamstrat" plats där nere, dels hyra de sängkläder åt hågade spekulanter och ställa de „hamstrade" skyddsrumsplatserna till förfogande då alarmet går. Här ses en samling ung-domar med täcken och dynor i barnvagnar vilka anlitas som transportmedel.

New Source of Income

Thanks to the bombing, London's poor have found a new source of income. Children gather round the exits of underground stations which serve as air-raid shelters. They have reserved places in the shelters and hire them out, with bedding, when there is an alert. Our picture shows a group of youngsters with mattresses and blankets carried in prams.

> Far older than their bombers is the hunger
> That they've unleashed on us. And to survive
> We have to earn the cash to buy provisions
> So, for survival, gamble with our lives.

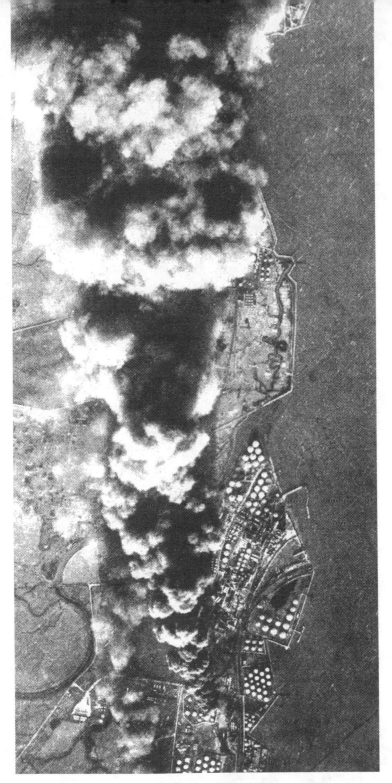

A cloud of smoke told us that they were here.
They were the sons of fire, not of the light.
They came from where? They came out of the darkness.
Where did they go? Into eternal night.

Strålkastarspel

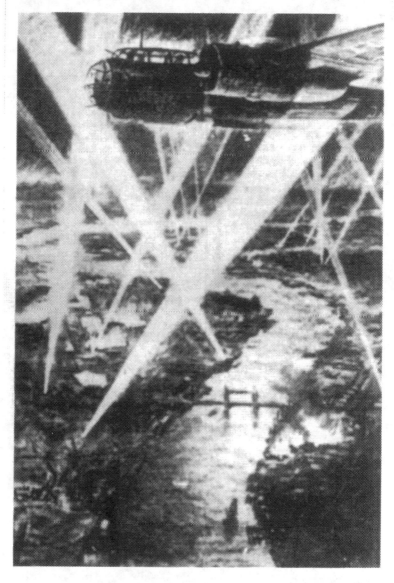

Vi återge här en bild från Associated Press, Berlin, framställande ett tyskt stridsplan, utsatt för engelska „strålkastarbatteriers" eld.

Searchlight display

We reproduce a picture from Associated Press, Berlin, showing a German fighter plane caught in English searchlights.

> What you see here, caught in your night defences
> These steel and glass cocoons for killing people
> With tons of bombs, are just the consequences
> For all, and not the causes of the evil.

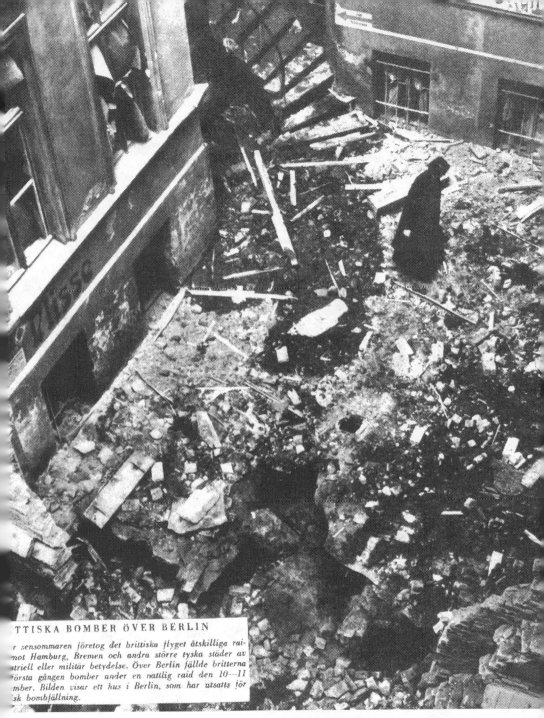

British Bombers over Berlin

In late summer 1940 the RAF mounted several raids on Hamburg, Bremen and other major German towns of industrial and military importance. The British bombed Berlin for the first time on 10/11 September. The picture shows a house in Berlin after a British raid.

> Stop searching, woman: you will never find them
> But, woman, don't accept that Fate is to blame.
> Those murky forces, woman, that torment you
> Have each of them a face, address and name.

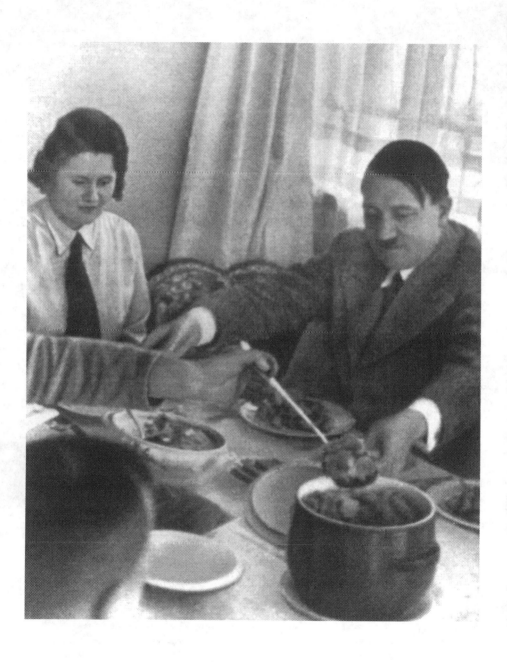

You see me here, eating a simple stew
Me, slave to no desire, except for one:
World conquest. That is all I want. From you
I have but one request: give me your sons.

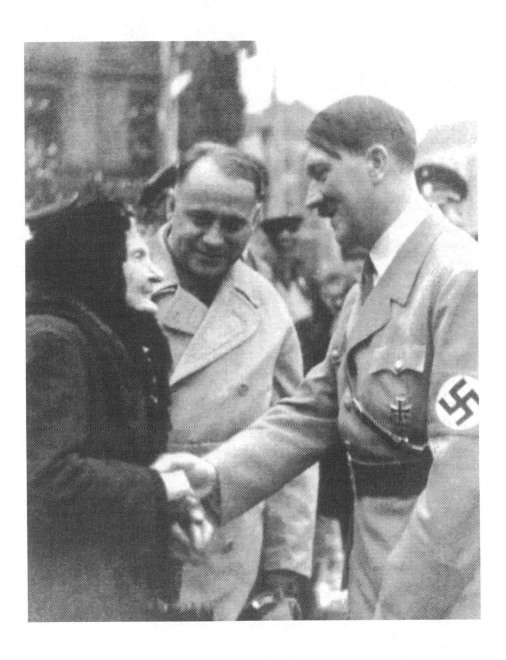

Suffer the old women to come unto me
That they may glimpse, before their graves close o'er them
The man their sons obeyed so faithfully
As long as he had graves left open for them.

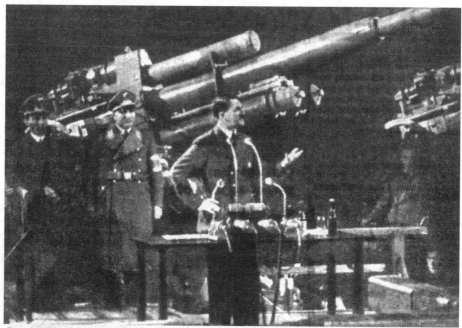

Den 10 december höll Adolf Hitler ett av sina stora tal i en vapenfabrik i närheten av Berlin. Vår bild visar rikskanslern och högste befälhavaren för den tyska krigsmakten på talarpodiet. T. v. om Hitler ses ledaren för den tyska arbetsfronten dr Robert Ley och riksministern dr Goebbels.

On 10 December Hitler gave one of his big speeches in an arms factory near Berlin. Our picture shows the chancellor and supreme commander of the armed forces on the podium, to his left the leader of the Labour Front, Dr Robert Ley, and Propaganda Minister Dr Goebbels.

Promising Socialism, there he stands.
Listen: a New Age will be proclaimed.
Behind him, see the work of your own hands:
Great cannon, silent. And at you they're aimed.

The saddler I, who helped the Junker scum
To get back in their seat. I'd no excuse
But let them buy me for a princely sum
From paupers' savings. And escaped the noose.

I am the butcher-clown in this concern.
The Iron Hermann, every time a winner
A Reich Marshal, policeman and thief in turn:
Give me your hand. But, first, best count your fingers.

I am 'the doctor', I doctor what gets printed.
It may be your world, but I have my say.
So what? Its history gets reinvented.
Even my club foot seems a fake today.

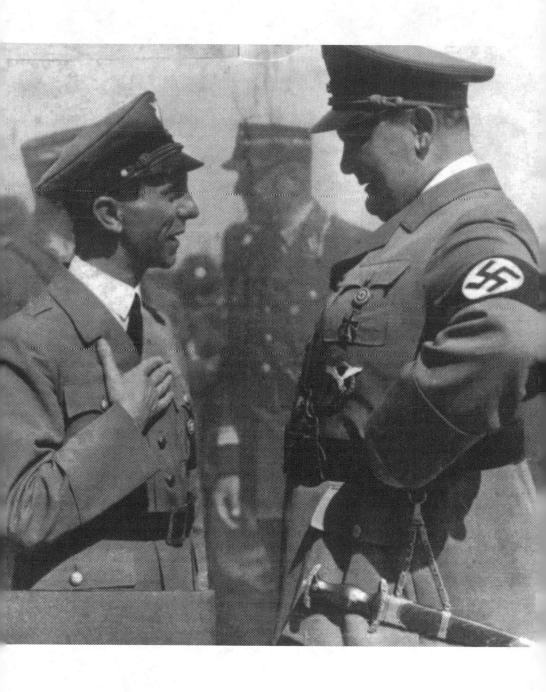

'Joseph, I'm told you're saying it's a fact
I loot things.' – 'Hermann, looting's not for you.
Who'd grudge you what you want? They'd have more tact.
And if I said it, who'd believe it's true?'

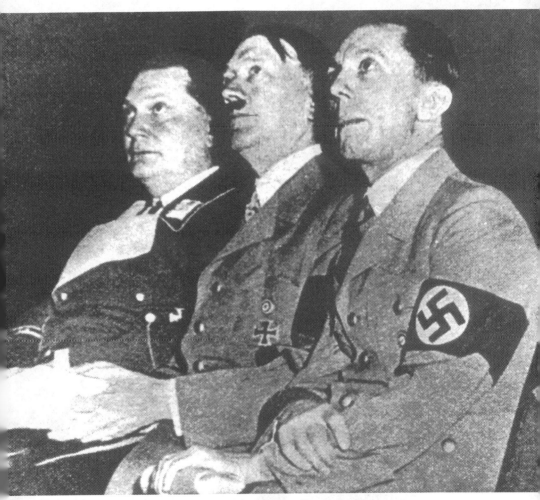

The Nazi Big Three—Their Ending Should Be Wagnerian.

O swan song! 'Never seek to question me!'
O pilgrims' choir! O fiery magic trick!
Song of the Rhine gold on an empty belly!
That's what I'd call the Bayreuth Republic.

Here's this stone horse outside the Chancellery
Who gazes glumly at the gloomy future.
'What's wrong then, horse?' 'My Leader had me try
His eight-year treatment, and I feel no better.'

German Churches on Wheels.
The Catholic Church has 38.
Berlin, Wednesday.
According to reports from Catholic circles, the Catholic Church now
has 38 churches on wheels. These consist of little altars mounted on
motor vehicles so that mass can be offered to isolated and inaccessi-
ble villages. A further dozen of these mobile churches are on order,
to reach – among others – remote army barracks. In general, the
padre himself drives his own mobile church.

A happy headline: God is on the move!
Hitler pushed on, and God could not keep up.
Well, such is war, let's hope God doesn't lose
Should he too find his oil's about to stop.

Ten countries lie prostrate beneath my tread
My own among them. And the bloody trace
Left by my boot has turned the country red
From Mülheim an der Ruhr to Kirkenaes.

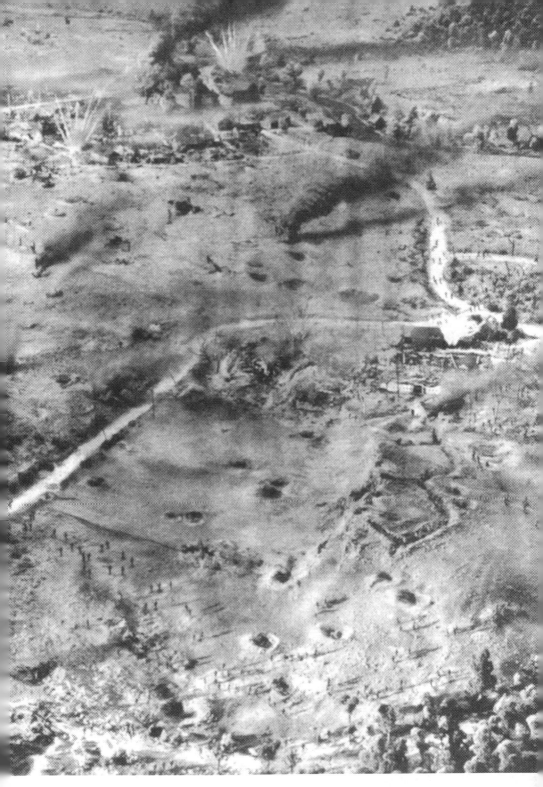

O brothers, see the distant Caucasus.
A Swabian peasant's son, I lie below
Killed when a Russian peasant fired on us.
I met defeat in Swabia years ago.

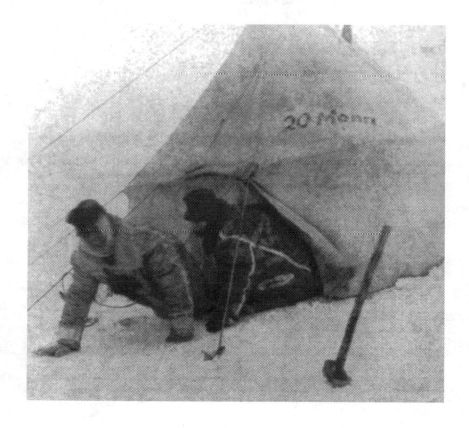

'What brought you two to North Cape?' – 'A command.'
'Don't you feel cold?' 'Chilled to the bone are we.'
'When will you two go home?' 'When this snow ends.'
'And how long will it snow?' 'Eternally'.

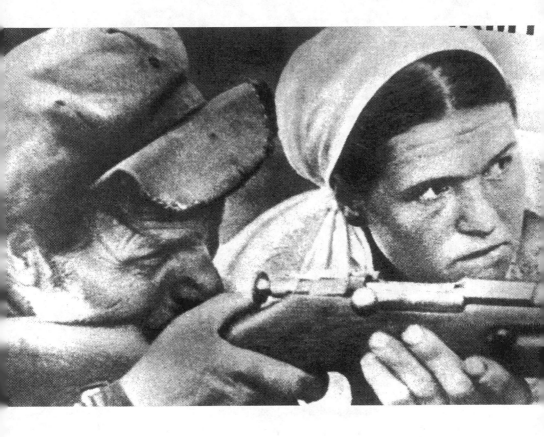

But when we sighted the red walls of Moscow
People appeared from farm and factory
And they repelled us in the name of every people
Even the people back in Germany.

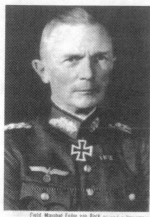
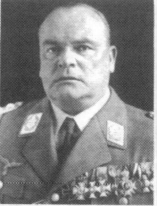
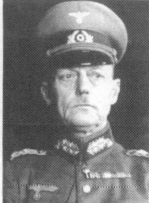

Field Marshal Fedor von Bock, 61 and a Prussian, helped conquer Poland, Paris and the North Caucasus.

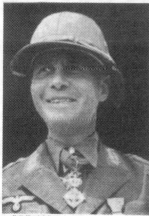

Field Marshal Fedor von Bock, 61 and a Prussian, helped conquer Poland, Paris and the North Caucasus.

Field Marshal Hugo Sperrle, 57, Bavarian brewer's son, commanded air corps in Spain, Poland, Lowlands, France, Battle of Britain.

Field Marshal Karl von Rundstedt, 66, planned and carried through famous break at Sedan, now has headquarters there.

Field Marshal Erwin Rommel, 50, is slashing, hard-hitting commander of the German Afrika Corps in Battle of Egypt.

General Heinz Guderian, 56, a Prussian, had brilliant tank successes in Poland and France, commanded Panzer division from a plane.

Field Marshal Siegmund List, 62, steely Bavarian master of mobility, knifed through Poland and France.

> Here are six murderers. Now don't turn away
> And don't just nod and murmur 'That's the truth.'
> Showing them up has cost us to this day
> Fifty great cities and most of our youth.

Look at the helmets of the vanquished! Yet
Surely the moment when we came undone
Was not when they were smitten from our heads
But when we first agreed to put them on.

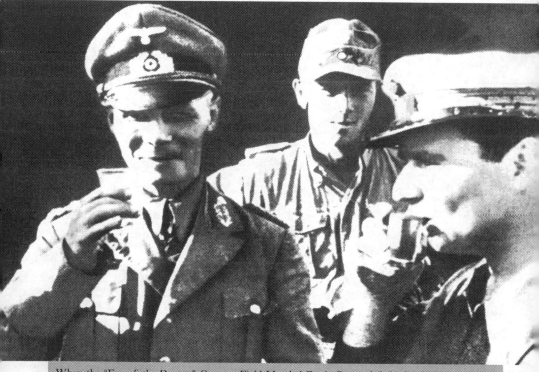

When the "Fox of the Desert," German Field Marshal Erwin Rommel (left) drank this premature toast, his *Afrika Korps* was still "unbeatable."

Here's to the Fatherland with all its Junkers!
The German sabre, plus its dividends!
The German People, armed and in its bunkers!
The great Misleader – Cheers! – of foes and friends!

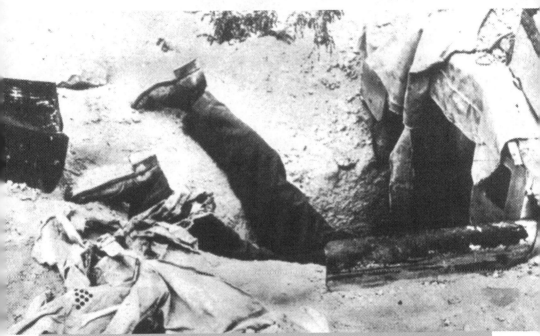

But in his recent flight across Libya, Rommel left behind many of his battered forces. From Allied attack this German vainly dived for cover.

O thrill of marching bands and banners flying!
Teutonic myth of swastika-crusaders dying!
Till all objectives were reduced to one:
To find yourself some cover. There was none.

Our masters fight to have you, lovely creature
They race to seize you in their headlong course.
Each feels most fit to bleed you white in future –
Most justified in taking you by force.

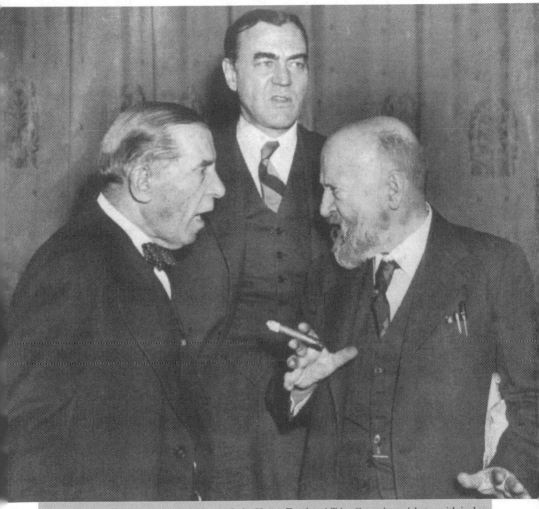

Statesmen at work: Chairman Sol Bloom of the House Foreign Affairs Committee debates with isolationist Holden Tinkham. Behind them: Hamilton Fish.

Behold us here, antagonists. See how
Each angry look is like a poisoned dagger.
A world of difference lies between us now.
The quarrel is: whose share's to be the bigger.

Here's what we sent, we people of Spokane
With a brassière to help support our Congress
In gratitude for their devoted service.
They asked for it. They'll know just what we mean.

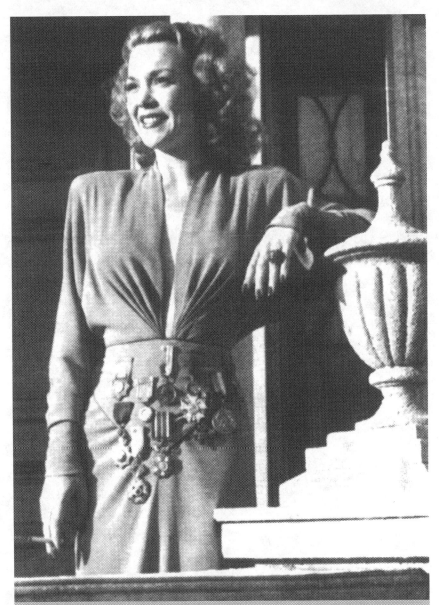

Jane Wyman shows her medals, adorning an 'R A F blue' dress designed by a Hollywood patriot who says girls 'should go military in a feminine way.' These are reproductions of old war medals and were not pinned on Jane for anything she did.

A breast curves through her military cut
Her parts are hung with old war decorations:
It's Hollywood v. Hitler. Here we've got
Semen for blood, and pus for perspiration.

Singapore Lament

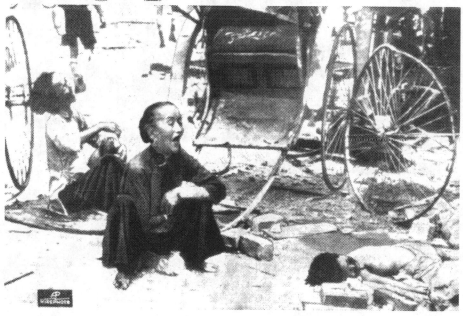

O voice of sorrow from the double choir
Of gunmen and the victims of the gun!
The Son of Heaven needed Singapore
And no one but yourself needed your son.

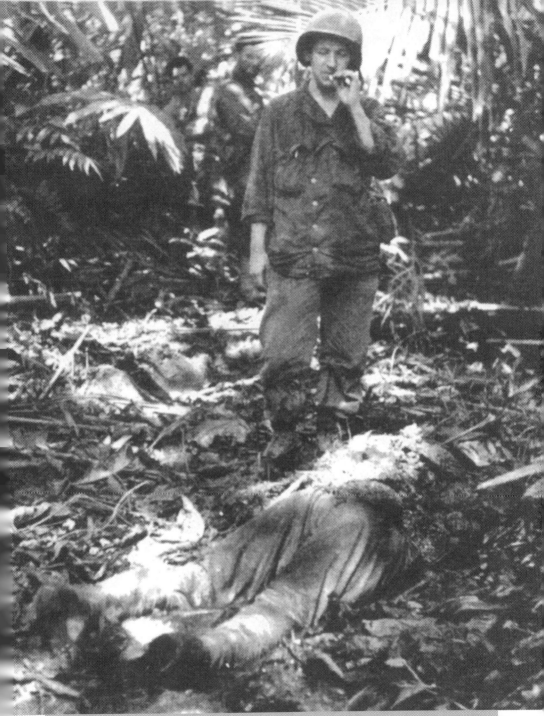

An American and the Jap he killed. Pfc Wally Wakeman says: "I was walking down the trail when I saw two fellow talking. They grinned and I grinned. One pulled a gun. I pulled mine. I killed him. It was just like in the movies."

We saw each other – it happened very fast –
I smiled, and both of them smiled back at me.
And so at first we stood and smiled, all three.
One pulled his gun. And then I shot him dead.

PICTURES TO
THE EDITORS
(continued)

SEXY CARROT

Sirs:

Responding to the current craze, nature has produced a pin-up vegetable. These shapely, satiny legs don't belong to some miniature Petty girl, but came from my victory garden. It is actually a twin-rooted carrot. When it was washed and de-whiskered I thought it looked quite fetching.

JOHN BRETHERICK
Philadelphia, Pa.

So you may have what you've been pining for
This sexy carrot might bring satisfaction.
A pinup for your tent on distant shores!
They say such pictures rouse the dead to action!

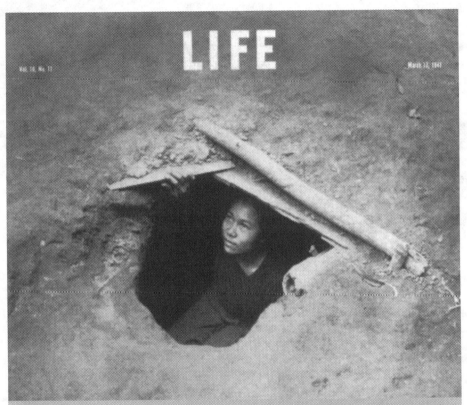

LIFE

Vol. 10, No. 11

March 10, 1941

Woman of Thailand (Siam) peers out of a crude bomb shelter in Sichiengmai at American bomber from French Indo-China come to bomb border hovels.

Hoping to keep concealed throughout the fighting
While would-be rulers wrestled in the air
The frightened people looked for holes to hide in
And watched their masters battling from down there.

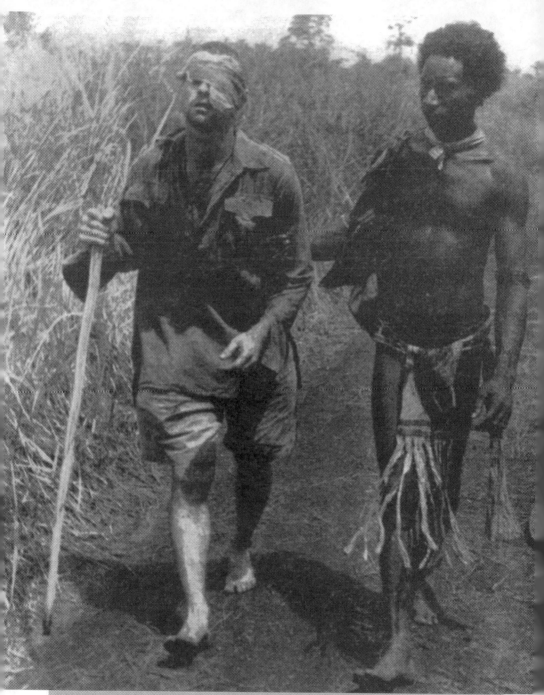

Back from the battlefront near Buna in New Guinea comes a blinded Australian infantryman helped by a kindly Papuan native. Both men are barefoot.

And when the bitter fight grew less intense
The man who helped me back was kind to me
And in his silence I began to sense
No understanding, but some sympathy.

...anese soldier's skull is propped up
burned-out Jap tank by U.S. troops.
...destroyed the rest of the corpse

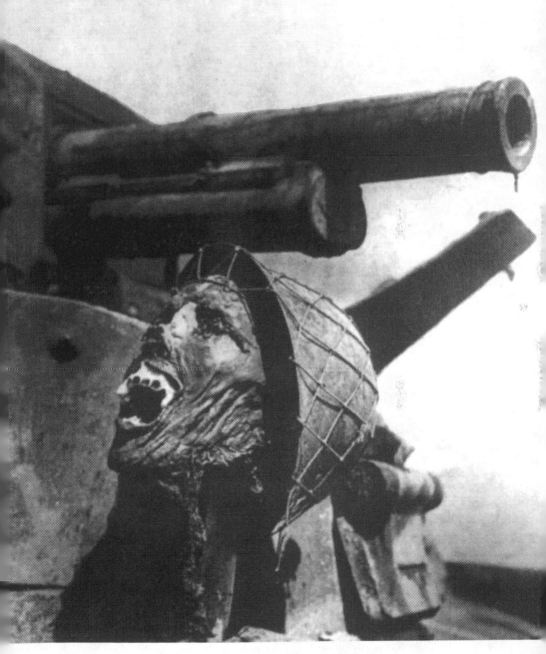

Alas, poor Yorick of the burnt-out tank!
Upon an axle-shaft your head is set.
Your death by fire was for the Domei Bank
To whom your parents still remain in debt.

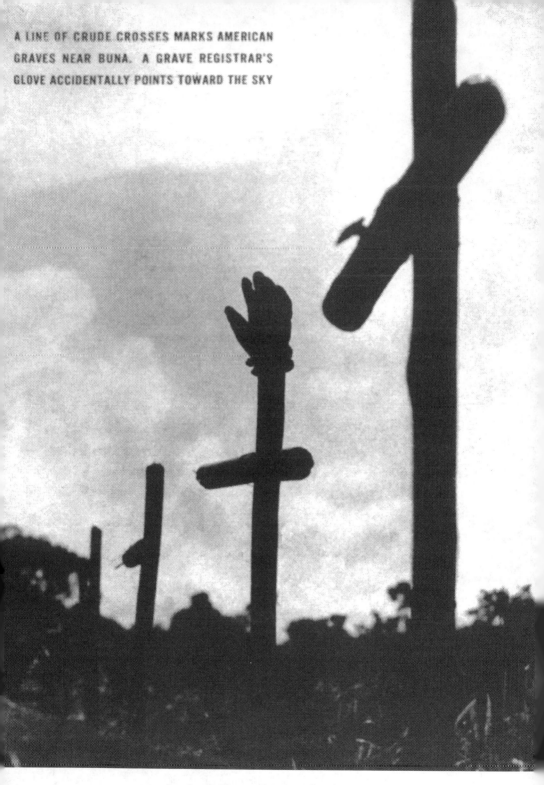

A LINE OF CRUDE CROSSES MARKS AMERICAN
GRAVES NEAR BUNA. A GRAVE REGISTRAR'S
GLOVE ACCIDENTALLY POINTS TOWARD THE SKY

In school we learned of an Avenger who
Would punish all injustice here on earth.
We went to kill, and met with Death. Now you
Must punish those whose orders sent us forth.

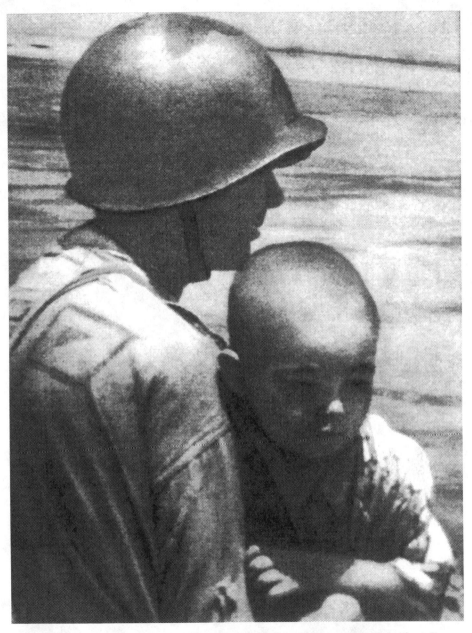

"This is a rough game we're playing, little fellow, and you wouldn't like it."
The Yankee solider removes a Japanese baby to safety.

Best take your enemy's little lost brother
Out of the battle line that you've defended.
That he and your son live to tell each other
Just how it was that wars like this were ended.

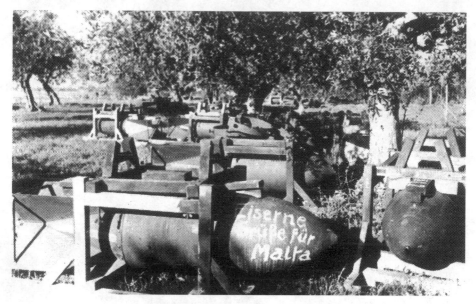

German bombs await use under olive trees.

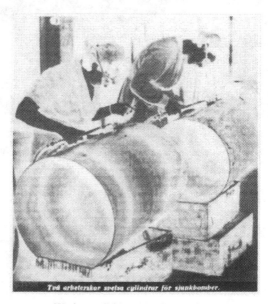

Workers polishing torpedo cylinders.

O olive tree, spreading your kindly leaves
To screen my brother's killers from the sun
You're like those women stooping, heads in scarves
To shape torpedoes for the common man.

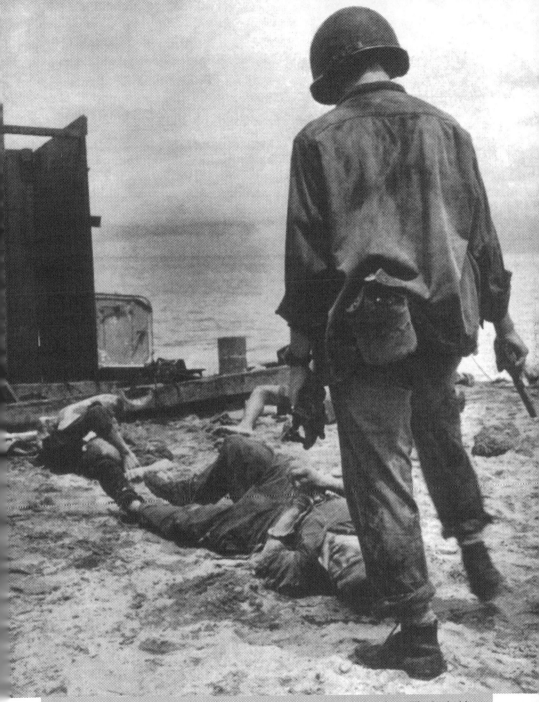

An American soldier stands over a dying Jap who he has just been forced to shoot. The Jap had been hiding in the landing barge, shooting at US troops.

And with their blood they were to colour red
A shore that neither owned. I hear it said
That they were forced to kill each other. True.
My only question is: who forced them to?

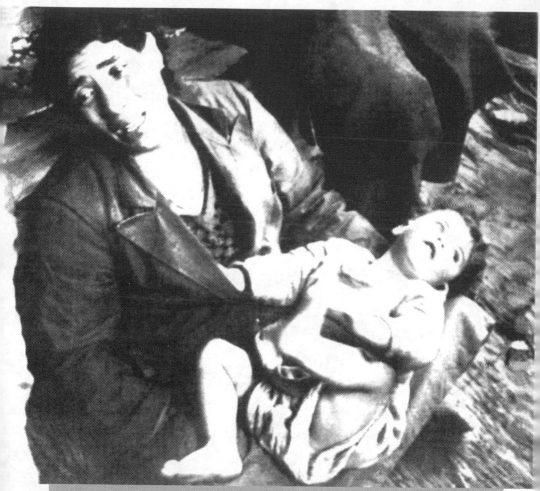

REFUGEES WITHOUT REFUGE: This Jewish mother and child were picked out of the sea, along with 180 others who sought refuge in Palestine. But 200 were drowned when the Salvator smashed on the rocky coast of Turkey. And the Salvator wasn't the first. The Patria exploded with 1771 aboard. The Penttcho foundered on an isle off Italy with 500. The Pacific was forced to sail from Palestine with 1062 and the Milos with 710. Then there is the Odyssey of the 500 Jews on a ship for four months, shunted from port to port. They come from all over Europe, packed like cattle in unseaworthy vessels. Where can they go, these 7,000,000 European Jews? Palestine's quota is 12,000 a year. The freighters and cattleboats carry a new kind of cargo—a new kind of human bootleg. Last year 26,000 were smuggled into Palestine. But what of the 7,000,000? The baby can play with his foot—for he's home in his mother's arms. He doesn't know his father was drowned in the Sea of Marmora. Only his mother knows the double-death of drowning in sight of shore.

And many of us drowned just off the beaches.
The long night passed, the sky began to clear.
If they but knew, we said, they'd come and seek us.
That they did know, we still were unaware.

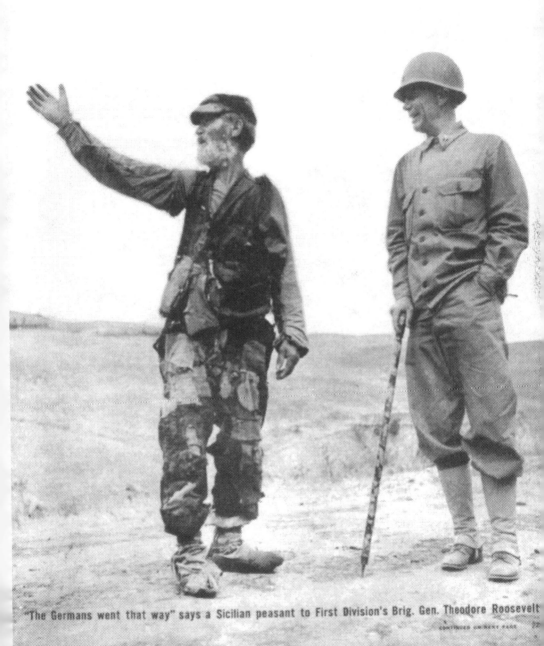

"The Germans went that way" says a Sicilian peasant to First Division's Brig. Gen. Theodore Roosevelt

Alas, our overlords have fallen out.
Over our country, waterless and blighted
Three foreign armies now are in dispute.
Only against us are all three united.

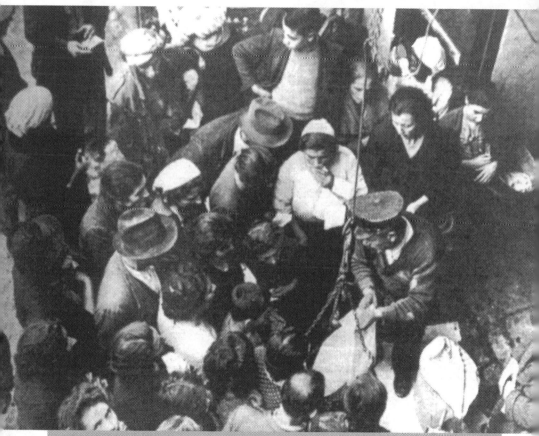

"Restoring the normal flow of life"—AMG officers sell American flour to Italian civilians.

We bring you flour, and a refurbished king!
Accept the flour and you must take the monarch.
Those who find licking boots is not their thing
Will have to settle for an empty stomach.

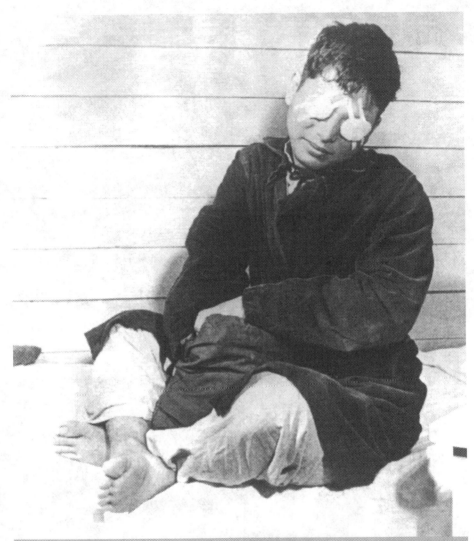

In Stark General Hospital, Charleston, SC, A young Japanese-American boy, blinded in Italy at the crossing of the Volturno River, sits patiently in bed.

Black out all towns, the sea, the starry heaven.
He'll glimpse no wife, nor ever yet a son.
Black out the morning skies, the clouds at even
Above Japan – and over Oregon.

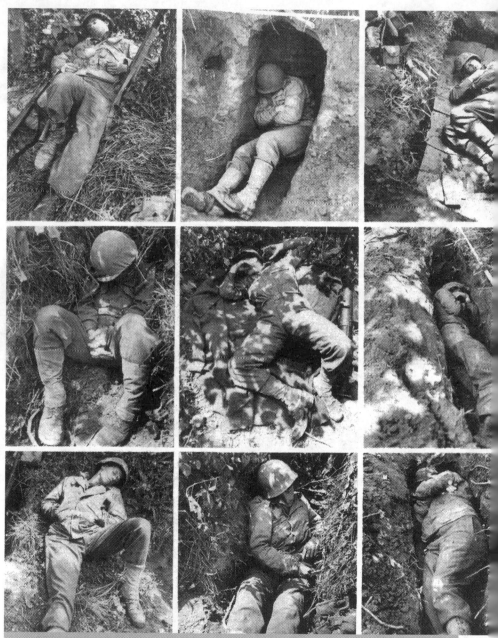

Exhausted soldiers, who have spent a day and a half getting into position, are photographed by LIFE's George Silk as they snatch a brief nap in the sun. Some of them dig deep foxholes but others, who disregard German fire, sleep unprotected on the ground. White tapes seen in some the pictures above mark passages through minefields cleared by engineers in the night.

Those you see lying here, buried in mud
As if they lay already in their grave –
They're merely sleeping, are not really dead
Yet, not asleep, would still not be awake.

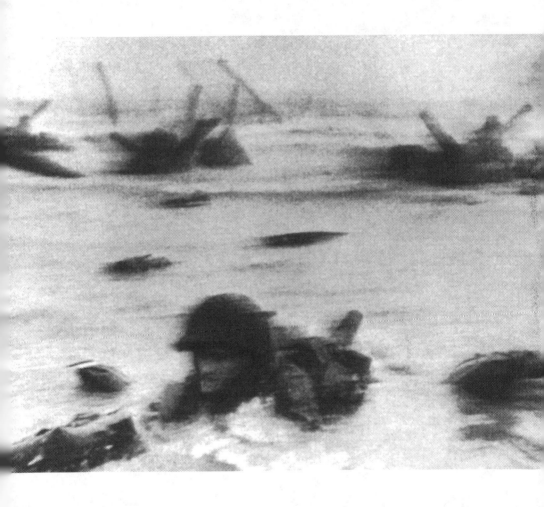

A summer day was dawning near Cherbourg
A man from Maine came crawling up the sand
Supposedly against men from the Ruhr
In fact against the men of Stalingrad.

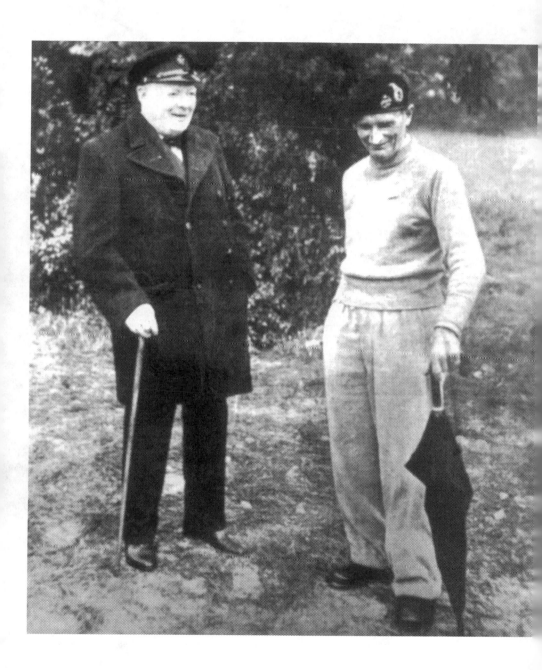

Welcome! But can we really count on you?
Of course there's courage in procrastination.
Think of that gent – he'd an umbrella too –
Who wanted Hitler first to beat the Russian.

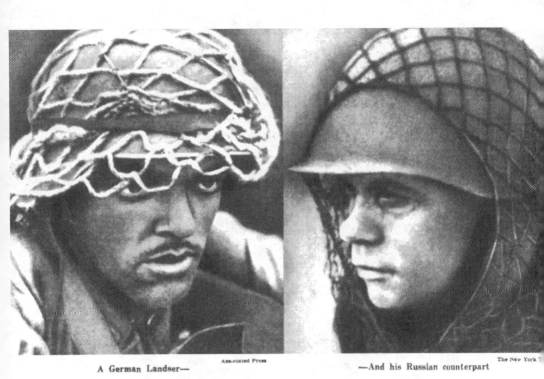

A German Landser—

—And his Russian counterpart

Here are two brothers, brought in armoured trucks
To quarrel over the one brother's land!
So cruelly the tamed elephant attacks
His brother, the unbroken elephant.

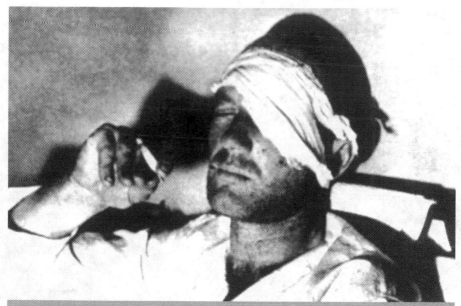

Blinded German soldier in a Moscow hospital.

Near Moscow, man, they stripped you of your sight.
Poor blinded man, you now know what wars mean.
Your great Misleader lost the Moscow fight.
Suppose he'd won, you still would not have seen.

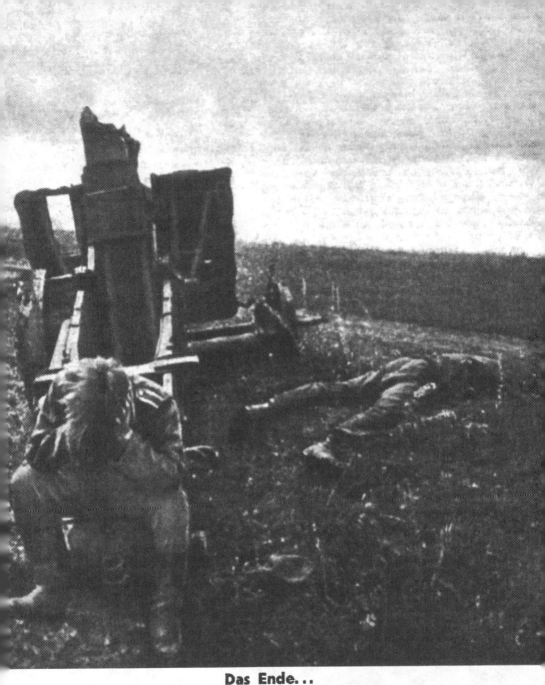

Das Ende...

eroffizier Georg Kreuzberg (86. I. D.) wurde von russischen Truppen auf dem Schlachtfeld von Orel in dieser Stellung angetroffen. Er ist geistesgestört.

The End ...
Corporal Georg Kreuzberg (86th Infantry Division) was found like this by Russian troops on the battle-field of Orel. He had gone mad.

I'm left to sit here holding my poor head:
Now the Misleader's fleeing from his troubles.
The cock that chokes on all the corn he's fed:
They'll go up in bubbles.

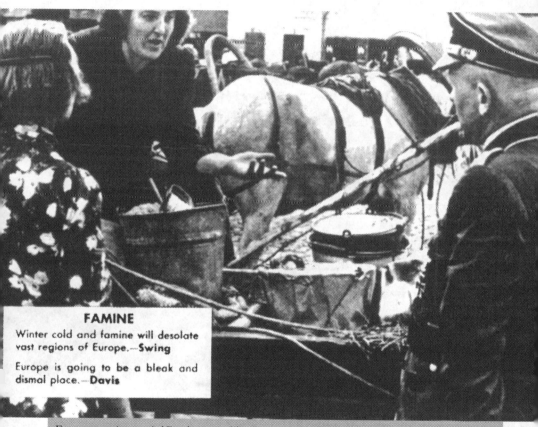

FAMINE

Winter cold and famine will desolate vast regions of Europe.—**Swing**

Europe is going to be a bleak and dismal place.—**Davis**

Farm women in occupied Russia argue with a German officer over the confiscation of grain and horses.

Much must survive, and much must be forgot
Much wisdom's needed where there's not much food
Much must take place, and much had better not
Before she knows she's lost that horse for good.

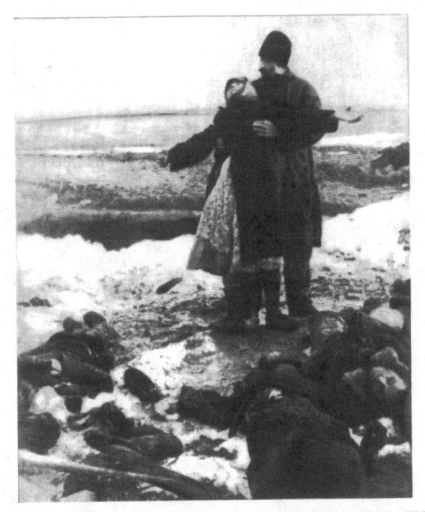

"AFTER THE LIBERATION OF KERCH BY OUR UNITS, THERE CAME TO LIGHT
THE SHOCKING DETAILS OF ONE OF THE MOST FIENDISH CRIMES THAT THE
GERMAN ARMY PERPETRATED ON SOVIET TERRITORY—THE SHOOTING OF OVER
7,000 CIVILIANS. THE GERMAN COMMANDANT'S OFFICE ASSEMBLED THE
POPULATION BY RUSE, HAVING POSTED ORDER NO. 4 DIRECTING THAT CITIZENS
WERE TO APPEAR IN SENNAYA SQUARE. AFTER THEY ASSEMBLED THEY WERE
SEIZED, DRIVEN OUTSIDE THE CITY AND MOWED DOWN BY MACHINE GUN FIRE."
—FROM THE NOTE ON GERMAN ATROCITIES ISSUED BY PEOPLE'S COMMISSAR
OF FOREIGN AFFAIRS VYACHESLAV MOLOTOV ON APRIL 27, 1942. THIS PIC-
TURE WAS TAKEN AS TWO PARENTS, RETURNING TO KERCH AFTER ITS RECAP-
TURE BY THE RED ARMY IN FEBRUARY 1942, IDENTIFIED THE BODY OF THEIR
SON.

> I say all pity, woman, is a fraud
> Unless that pity turns into red rage
> Which will not rest until this ancient thorn
> Is drawn at last from deep in mankind's flesh.

Return to Homesite

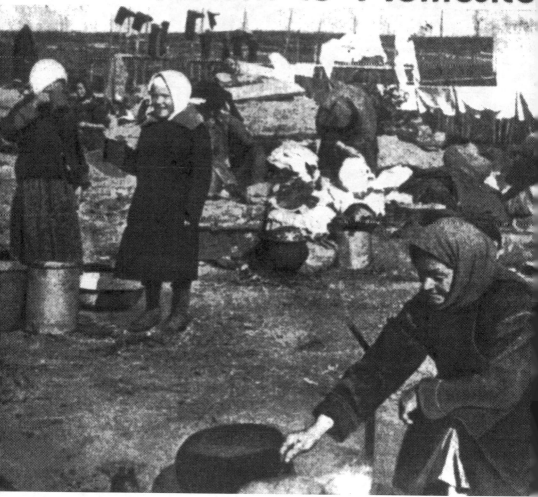

It seems to me that I'd destroyed your home
Because it was my brother, curse the day!
There was no brighter hour than when I learned
You'd conquered him and driven him away.

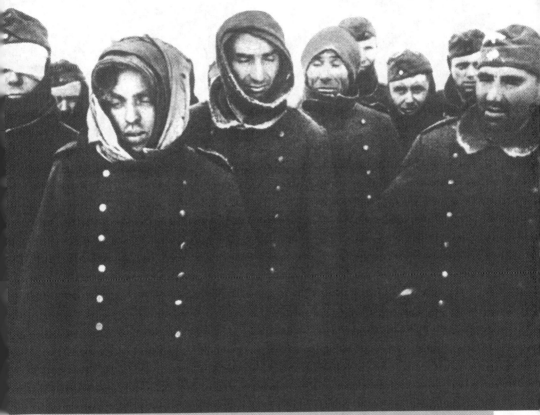

The face of the German Army in Russia now appears frozen, dazed, exhausted of will or pride. These were once crack troops, the terror of the world of 1940 and 1941 but the farther they got into Russia, the less they liked the cold and the ample room to die in. However, as the handy Russians advance westward, the warmer it feels and the more delightful the prospects grow.

These are our children. Stunned and bloody-faced
Out of a frozen Panzer see them come.
Even the vicious wolf must have a place
To hide in. Warm them, they are getting numb.

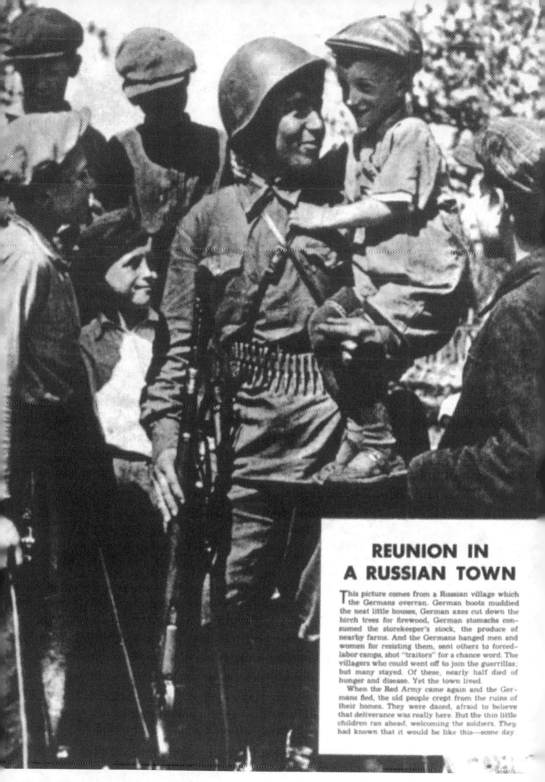

REUNION IN A RUSSIAN TOWN

This picture comes from a Russian village which the Germans overran. German boots muddied the neat little houses, German axes cut down the birch trees for firewood, German stomachs consumed the storekeeper's stock, the produce of nearby farms. And the Germans hanged men and women for resisting them, sent others to forced-labor camps, shot "traitors" for a chance word. The villagers who could went off to join the guerrillas; but many stayed. Of these, nearly half died of hunger and disease. Yet the town lived.

When the Red Army came again and the Germans fled, the old people crept from the ruins of their homes. They were dazed, afraid to believe that deliverance was really here. But the thin little children ran ahead, welcoming the soldiers. They had known that it would be like this—some day

Holding a child, and with your rifle grounded
Staking your life on the new life you're building
Let's see you, once this bloody war is ended
Surrounded by a crowd of German children.

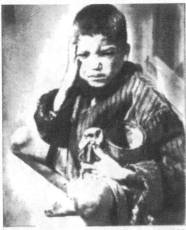
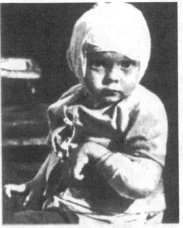
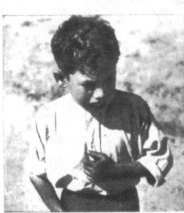
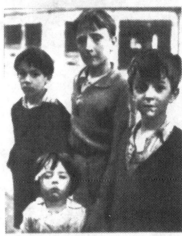

Greek boy swollen with hunger is a grim reminder that one third of Athens' children died of starvation, nine out of ten newborn were dying. Conditions were so terrible that the United Nations allow Greek relief to pass through the blockade.

Russian children are among those who have suffered most at the hands of the Nazis. Besides witnessing the rape of their home towns, many have been wounded in battles which rage like prairie fires across the devastated Russian plains.

A Sicilian lad who saw his parents killed by Germans finds, like other bewildered young Italians, that war has blotted out his sun. He will learn that Allied control ends such injustices as children toiling like moles in the sulpher mines.

French children – listless little ones standing silently in school yards at recess time, roving the street in search of bread – are too tired and hungry to play normally or remember their lessons. Tuberculosis is steadily on the increase.

> You, in your tanks and bombers, mighty warriors
> You that in Algiers sweat, in Lapland freeze
> In scores of battles you have been victorious
> See whom you've conquered. Hail your victories!

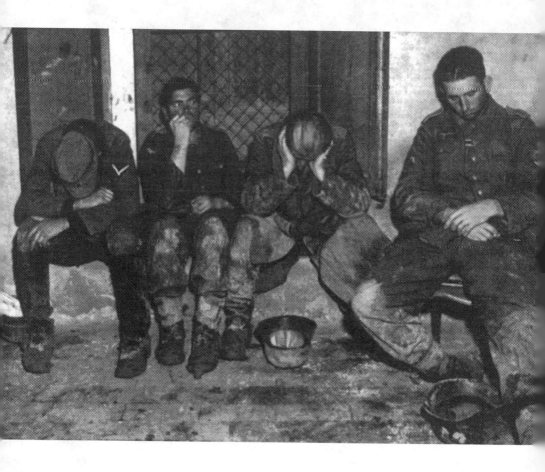

Worn out by battle, if you only had
Sufficient strength now for yourselves to fight
The world, in death- and birth-pangs, would be glad
It took the pains that led to your defeat.

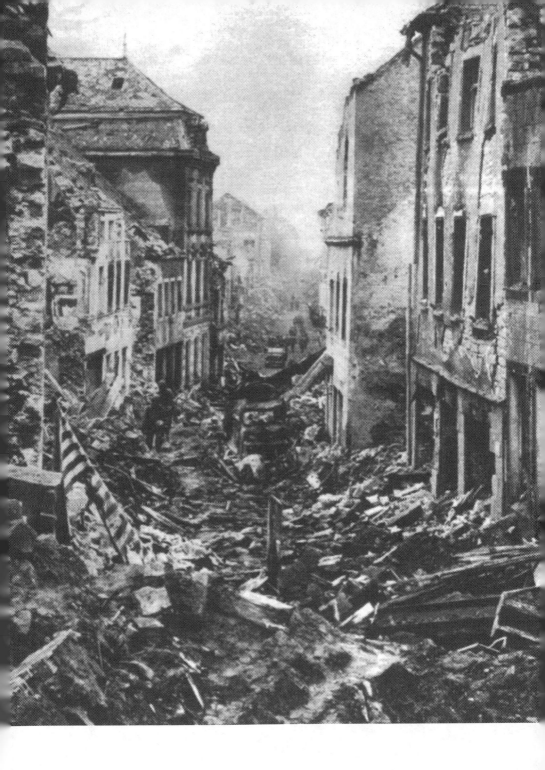

Here are the cities in which once our 'Heils!'
Acclaimed our war machine as it paraded.
But these are nothing to the thousand miles
Of foreign cities that it devastated.

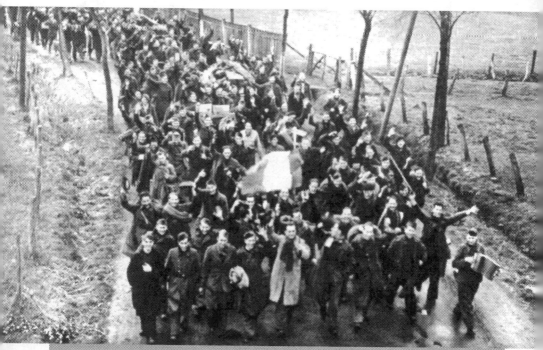

Returning to a changed world – French soldiers, released after five years of captivity, march down a road in Germany on the first leg of their journey home.

Homecomers back from inhumanity
Tell those at home of life among a folk
That tamely bowed its head beneath the yoke
And don't assume that you are truly free.

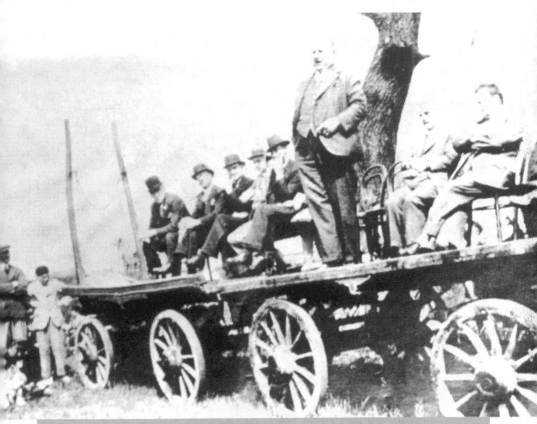

Campaigning for the Labor Party. Bevin speaks from the proletarian platforms like these old carts. He ran for Parliament twice before he was elected from a London district in 1940. Although he is only 5 ft., 5 in. tall, Bevin gives an impressive platform air but he has to watch his weight. He used to weigh 250 lb., now weighs 200.

This fat man wants a job. I beg you all
To vote for him; he speaks for common sense!
But vote him up that tree, where he'll stand tall –
Not for a job, and not at your expense.

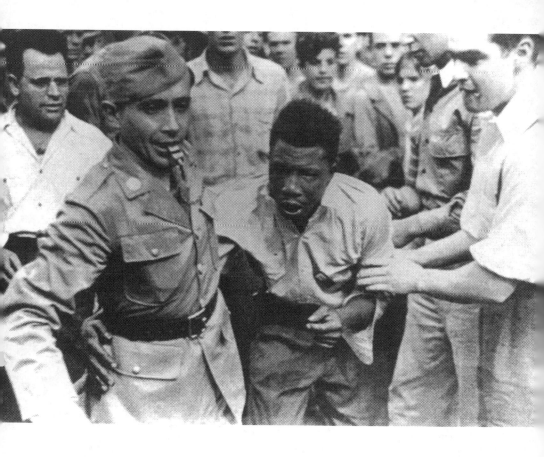

Outside the City Hall, beaten and bloody
A GI rescued me. He was my friend
And showed more courage there than anybody
At Kiska or Bataan or the Ardennes.

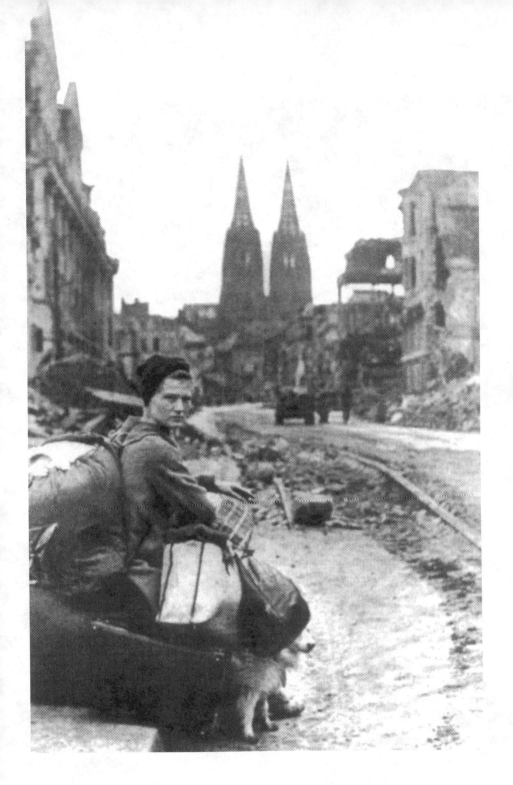

I hear the men of Downing Street accuse you
Saying you stuck it out, so it's your fault.
They may be right, but when did they last choose to
Chide people's strange reluctance to revolt?

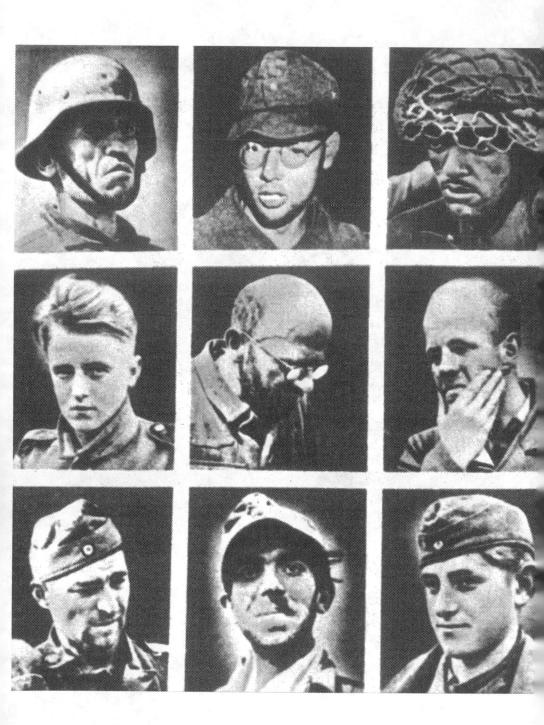

I thought I knew you, and I think so yet.
And I'm not one of those that blindly praise:
I say you're good for more than blind world conquest
In servitude as slave driver or slave.

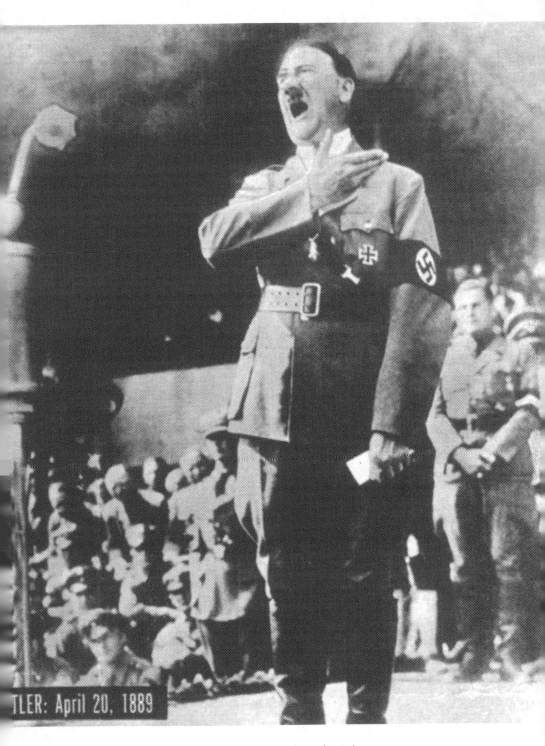

TLER: April 20, 1889

That's how the world was going to be run!
The other nations mastered him, except
(In case you think the battle has been won) –
The womb is fertile still from which that crept.

81

I was the bloodhound, brothers. That's the name
I gave myself, the working people's son.
They recognised it; then the Nazis came
And housed and pensioned me for what I'd done

STAMP OF APPROVAL—
Bunny Waters, bathing ——▶
beauty, decided on this
unique method of selling
Defense Stamps to passen-
gers on train out of New York.

If we can have the right to touch her up
She'll find that we are quite prepared to spend
From our own pocket or some other chap's.
That's how it started. How's it going to end?

FUTURE AIR war on the northern roof of the world will be carried on by warriors dressed like this U.S. soldier, who, looking like a man from Mars, is wearing clothing specially designed for service in the Arctic.

You women back in Pittsburg and Texas
D'you really want your sons to look that way?
You know those sons are being sent to us –
Are we to be attacked by beasts of prey?

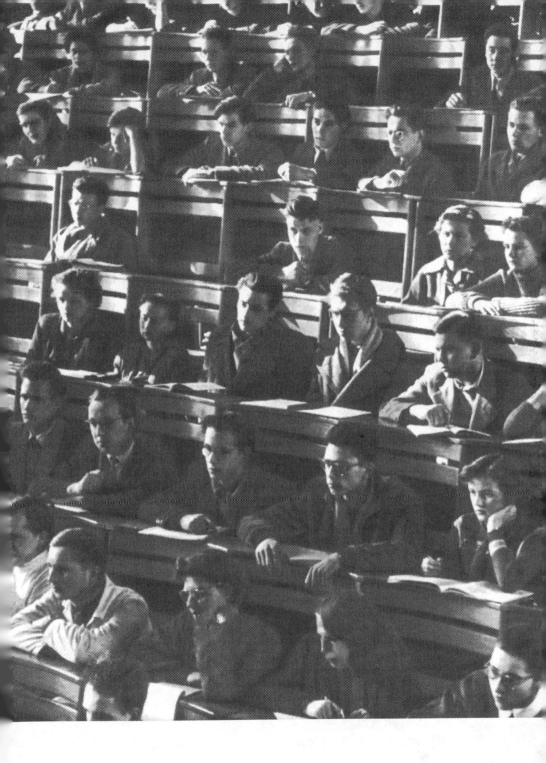

Never forget that men like you got hurt
So you might sit there, not the other lot.
And now don't hide your head, and don't desert
But learn to learn, and try to learn for what.

AFTERWORD

From the Fall of Barcelona to the Death of Hitler

At the beginning of 1940 a number of causes combined to inspire Brecht to a new kind of war poetry that would match epigrams (in the lapidary tradition) with photographs from the mass-circulation press. A decade earlier he had become interested in the use of photography in the *AIZ* (*Arbeiter-Illustrierte Zeitung*), the German 'Workers' Illustrated', whose approach he publicly welcomed in 1931 (the year when it printed his poem 'Coals for Mike'). Later, as an exile from Hitler's Third Reich, he defended John Heartfield's photomontages for that journal against Moscow's criticism of their 'formalism', treating Heartfield as a politically committed innovator along with Hanns Eisler, Erwin Piscator, George Grosz and himself. Heartfield's brother, Wieland Herzfelde, became Brecht's publisher in Czechoslovakia until the country's fall in 1939 forced both brothers to look for work in London and New York. By then the *AIZ* had closed, after changing its name to *Volks-Illustrierte*. Its publisher, Willi Münzenberg, founder of the German Worker-Photographers' movement, was expelled from the Comintern, interned in France, and mysteriously murdered after his escape.

In January 1940 Brecht began sticking press photographs in his *Journals* – the 'Arbeitsjournal' that he had started systematically keeping just before the Munich Agreement. This was at a time when his poems were becoming more compact and concentrated. In 1937 he wrote a set of anti-Nazi epigrams under the title 'German War Primer', which were published in the Moscow magazine *Das Wort* and impressively set by the composer Hanns Eisler as variations for unaccompanied chorus titled, *Against War*. Those epigrams differed from the present collection in being unrhymed, irregular in form, and imaginatively concerned with a war that had not yet broken out. Probably the best known is:

> ON THE WALL WAS CHALKED:
> They want war.
> The man who wrote it
> Has already fallen.

Like the 'German Satires' intended for the underground Freedom Radio, these were included in *Svendborg Poems*, named after the Danish town near where the Brechts spent their first years of exile, and published by Herzfelde in May 1939 under the imprint Malik-Verlag London. This was four months before Hitler's invasion of Poland unleashed the Second World War. Before leaving Denmark that spring for the greater security of Sweden, Brecht also wrote the poem 'Bad Time for Poetry', which contrasts the beauty of the Svendborg setting with the silent horrors, and includes the lines

> In my poetry a rhyme
> Would seem to be almost insolent.

That same year Brecht nonetheless started to write rhymed quatrains, initially as mottoes for *Svendborg Poems* and the 'Steffin Collection' that followed (named after his main collaborator of that time). In the middle of 1940 Brecht noted in his journal that 'at present all [he could] write [were] these little epigrams, first eight-liners and now only four-liners'. By then, he and his family had left Sweden for Finland, with the intention of moving on to the United States as soon as their documentation was complete. Meanwhile, the war had begun to spread with the German invasion of Norway and Denmark. No sooner had the Brechts found an apartment in Helsinki than Hitler's blitzkrieg in the West was launched. First came the conquest of France, then the steady pounding by the Luftwaffe of English cities as a prelude to the next invasion.

So Brecht now had an ongoing theme for his quatrains, which he could pursue during the months of isolation in the lovely Finnish countryside, while just around the same time a possible focus for the accompanying images was suggested by August Oehler's German translation of Greek epigrams that his son had brought to him. 'In ancient Greek epigrams', he wrote in his *Journals* on the eve of the London Blitz, 'man-made utensils are straightforward subjects for lyric poetry' – illustrating this with cuttings of photographs of an aeroplane cockpit and three types of makeshift grenade used by the British Home Guard. Compare the German bomber crew in no. 16, or the anti-aircraft gun under whose shadow Hitler speaks in no. 28. Such pictures added a certain concreteness to what Brecht termed 'the linguistic cleanup' (or laundering of language) that his verses were aimed for, though it is not impossible that there was an English influence at work here too. Kipling, whose example is known to have touched Brecht at various points, wrote some First World War epitaphs that prefigure *War Primer* – for instance the rhymed quatrains 'R.A.F. (Aged eighteen)' and 'Raped and Revenged':

> One used and butchered me: another spied
> Me broken – for which thing an hundred died.
> So it was learned among the heathen hosts
> How much a freeborn woman's favour costs.

These have the structure, though not quite the substance, of much that can be found in this book.

At the same time, Brecht's step-by-step progression had something in common with the sequence of scenes in *Fear and Misery of the Third Reich*, the disjointed episodes that he had strung together on a chain of twenty-seven verses so as to add up to a formal parade (or march-past) of Nazi Germany on the eve of war. Both that play and *War Primer* could be compared with a still greater precursor: Goya's *Disasters of the War*.

The first batch of photo-epigrams starts with Hitler in visionary mood before the microphones, followed by one or two references to what many regard as the fatal prelude, the Spanish Civil War. The Polish campaign is almost ignored, the Russo-Finnish war of winter 1939–40 entirely so. The conquest of Norway in spring 1940 is followed by Hitler's drive through the Low Countries into France, culminating in that country's capitulation in late June. Up to this point the Russians are unmentioned, having been dubiously allied with Germany since the first days of the war; indeed, Brecht has nothing to say about them till much later, except privately in the pages of his *Journals* (which are often devastating on this subject). The main centre of interest for him in those twenty-odd poems,

rather, is the Blitz as seen not only from the sky, but also from the shelters and from the point of view of those using them. How far Brecht could sympathise with those in the shelters is not always clear, but we get glimpses in the *Journals*, with their feeling for English literature. Until June 1941, Britain under Churchill represented the world's only substantial resistance to Hitler, and this was not concealed in the Swedish illustrated magazines on which Brecht at first almost entirely depended – supplemented of course by the little radio set about which he wrote a moving (eight-line, rhymed) poem in the course of 1940 that is in his 'Steffin Collection'.

In spring 1941, as the British army became engaged with the Afrika Korps in Libya, the Brechts' American visas came through and they left Finland for Moscow, the Trans-Siberian Railway, and Vladivostok, where they boarded a Swedish ship for California. Margarete Steffin was too ill to continue beyond Moscow, and died there of tuberculosis under the care of the Writers' Union. Then, only nine days after they sailed, Hitler launched his massive attack on Soviet Russia, surrounding Leningrad by September before being brought to a halt near Moscow. This sudden invasion entirely changed not only the course of the war, but also the Communist interpretation of it as a conflict between imperialist powers (which Brecht had on the whole accepted). At the same time, the move to the United States and the loss of his key collaborator had a paralysing effect on his will to work, so that he made only a few sporadic additions to *War Primer* over the next two years. Then in the autumn of 1941 he wrote 'The Children's Crusade', a long poem in memory of Steffin. At the end of the year came another long poem, 'To the German Soldiers in the East', written, he noted, 'after much talk about sending material to Moscow', presumably for its German-language broadcasts. He was now able to take most of his picture cuttings from *Life* magazine, which seems to have been only fitfully available to him in Finland, and starting in August of that year, he illustrated his journal almost entirely with photographs concerning the Russian front.

It was not until midway through his second year in the United States that he once more began seriously collecting *War Primer* photographs. This was during his first visit to New York. Starting within a few days of arriving in the city, Brecht first concentrated on images of America's Pacific War, hitherto unrepresented in the sequence although it had been going on for some eighteen months. The only such image in the *Journals* meanwhile was the picture of the 'silent scream' from Singapore, which appeared as no. 48 in *War Primer*. Of course it is seldom possible to say when Brecht first conceived any particular epigram, but this batch of pictures dating from February 1943 is linked to quatrains now attributed to 1944 (which may only represent the date when the page in question was ready). There are fifty such epigrams in addition to the twenty-five or so written before leaving Finland. Some are linked to earlier photographs, and several could have been drafted before the end of 1943. The only clear indication given by Brecht himself is a *Journal* entry made in California soon after he sent off the first version of *The Caucasian Chalk Circle*. This reads:

20 jun 44

working on a new series of photo-epigrams. as i look over the old ones, which in part stem from the beginning of the war, i realise that there is almost nothing i need to take out (politically nothing at all), proof of the validity of my viewpoint, given the constantly changing face of the war. there are now about 60 quatrains, and along with FEAR AND MISERY OF THE THIRD RIECH, the volumes of poetry, and perhaps FIVE DIFFICULTIES IN WRITING THE TRUTH, the work offers a satisfactory literary report on my years in exile.

'Satisfactory', that is, from the political point of view, though that was not all. Those years had also seen the writing and first production of *Mother Courage*, the *Good Person of Szechwan* and the first version of *Galileo*, although it is curious that Brecht does not mention these.

Clearly something had happened to turn Brecht's attention back to the project, and it seems likely that this took place in New York (where he would pay a second visit in winter 1943–44). There he renewed contact with many of his Berlin friends and colleagues, notably those whom he knew from the theatre: Erwin Piscator, Kurt Weill, Lotte Lenya, his old impresario Ernst Josef Aufricht, as well

as Elisabeth Bergner and Peter Lorre, who he socialized with in Hollywood. With Piscator's support, a 'Brecht evening' was held at the New School Studio Theatre on 6 March 1943 by 'Die Tribüne', an anti-fascist writers' group organised by Friedrich Alexan. There were readings and songs with Bergner and Lorre, while Alexan's friend the composer Paul Dessau played the piano. He impressed Brecht at rehearsal, and when his singer dropped out, Brecht made him sing a song from *Saint Joan of the Stockyards*. This, it seems, persuaded the writer to invite Dessau to California, where he would duly become part of the extended Brecht family. Some weeks later there was a repeat programme at the Heckscher Theatre on East 104th Street, where the actor Herbert Berghof read from something called Brecht's *Contemporary Picturebook* accompanied by projections. This was almost certainly a selection from *War Primer*.

Dessau told Brecht that he was hoping to write a big choral work, a German requiem, but more of a lament than Brahms's work with that title: 'a vast *Miserere*, a German work portraying the immense tragedy of our fatherland', he would tell Hans Bunge in 1958. Brecht put the epigrams at the composer's disposal, along with other, earlier poems, and the two men intermittently discussed progress until 1947, when the work was finished. A further factor in the realisation of the epigrams was Brecht's meeting with Elisabeth Freundlich, arts editor of the monthly *Austro American Tribune*, who he was introduced to Berthold Viertel. She published the first three of the photo-epigrams to appear in print, starting with no. 70 in her February 1944 issue. One way or another it is evident that Brecht had found enough encouragement to make a substantial book of them, and by the late summer he had collected seventy or more. Then it was a matter of getting them duplicated and pro-visionally bound. Ruth Berlau, with whom he had been living when in New York, had taken a photo-graphy course in that city before coming to Los Angeles in the summer. There she started making photographic copies of the 'Poems in Exile', the 'Studies' (i.e. the literary sonnets), *War Primer, The Caucasian Chalk Circle, Schweyk in the Second World War* and a number of other works that would be deposited in the New York Public Library on 21 March 1947. *War Primer* (in German, *Kriegsfibel*) was ready for possible publishers.

As things turned out, it would not be published anywhere until 1955, ten years after the German surrender and only a year before Brecht's own death. The reasons for this, and the shabby story of the work's various submissions and rejections after Brecht's return to Europe, will be dealt with below. It reflects a different kind of war, for which no primer has been written. There would be moments when the poet spoke of compiling a 'Friedensfibel' or 'Peace Primer', and quatrains like no. 84 (which dates from 1950) were supposedly to be part of that. The fine epigram to the picture on the back of the dust jacket, no. 85, with its worker-students at their desks, would be set to unconvincingly optimistic music by Eisler as a finale to his *Bilder aus der Kriegsfibel* (Pictures from the War Primer), an other-wise masterly composition (see p. 93 below). The idea of a *Cold War Primer* was never mentioned.

From Capitulation to Publication

Though the war had ended in 1945, the Brechts spent another two years in the United States before returning to Europe. Hardly anything was added to the seventy-one photo-epigrams that made up the would-be book. Dessau completed his *German Miserere* in 1947, but it was eight years before it would be performed. The first approach to a German book publisher was only made in autumn 1948, when Brecht was based in Zurich, still wondering how to arrange his new life. Then, Ruth Berlau offered it to the publisher Kurt Desch, of Munich in the US occupation zone, who was also negotiat-ing for the *Poems in Exile*, which he thought of copublishing with Wieland Herzfelde and the Soviet-licensed Berlin firm Aufbau-Verlag. But Desch turned *War Primer* down and returned the script in November 1948.

Early the next year, following the epoch-making Berlin production of *Mother Courage*, Brecht and Helene Weigel settled in East Berlin, where they established their Berliner Ensemble. There, *War Primer* was sent to an East German publisher, Volk und Welt, under the direction of Michael Tschesno-Hell, formerly the editor of a journal for exiles like himself who had been interned in Swiss

labour camps. Suggestions at this stage included the discarding of the pictures of Ebert (no. 29), the first President of the Weimar Republic (tactless to the Socialist comrades), Goering (no. 30) (too flattering), Ernest Bevin (no. 77) and possibly Rommel (no. 42) (who had eventually turned against Hitler). But it still had to be submitted to the official licensing authority of the newly founded state, the German Democratic Republic. In March 1950, its publishing watchdog, the 'Kultureller Beirat für das Verlagswesen', found that it was too 'broadly pacifist in its opposition to the war', and fell short of Brecht's supposed intention 'to make a contribution against the imperialist warmongers'.

In the now dominant context of the Cold War, where 'warmongers' meant the Americans and their allies, Kurt Pincus of the Beirat thought it wise to get the opinion of the ex–Social Democrat Premier Otto Grotewohl. On 13 March, two days after receiving Pincus's letter, this man took a green pencil and wrote in a large firm hand:

Send it back.
 I entirely agree with your view: totally inadequate.
 Gr.
19.3.50

His rejection was communicated to Brecht a week later by Stefan Heymann of the Socialist Unity Party (SED). Having been its director of Culture and Education since the beginning of 1949, Heymann now told Brecht that the book's final warning (no. 81) about a rebirth of Nazism would be weakened by its focus on Hitler. This applied to the opening as well as to the closing image; Brecht should instead be showing Hitler as an agent of the arms manufacturers. Heymann also disliked the conclusion of the Spanish War quatrain (no. 4) that 'God is a Fascist'; the idea of nothingness ('eternal night') in no. 23; the characterisation of Noske (no. 82) (who was substituted for Ebert, no. 29) as 'the working people's son'; the suggestion that the Chinese 'watched ... from down there' (no. 51) when in reality they were directly involved; and finally the insulting idea, in no. 65, that a 'Red Army fighter' could be portrayed alongside a 'fascist soldier' so as to 'sweep under the mat the significance of the Soviet Union's Great Patriotic War'. All these points, he felt, could still be corrected in such a way as to greatly increase the value of the book.

There is a typed response by Brecht, unsigned, which may or may not have been sent. In it he contested all these points except the one concerning the need to show the forces behind Hitler. He did think he had some discarded quatrains that might do this, and would try to find them. Above all, however, he argued that the book had been finished in 1945, at the end of the war, and therefore 'had to be taken historically'; it would be a falsification if he were to make many changes. All the same, he realised that it might be a good idea to add notes at the end of the book to 'avoid misunderstandings and clarify the documents'. Thereafter the script appears to have lain in the drawer for the next four years or so, during which Brecht was concerned in a number of conflicts with the cultural authorities, notably the controversy over his *Lucullus* opera in 1951, the debates about Stanislavsky's somewhat retrograde ideas of Realism, and the disputes over *Faust* – both the Berliner Ensemble's Potsdam production and Hanns Eisler's radical opera libretto, which had to be abandoned as a travesty of the 'cultural heritage'. There were just some small alterations to *War Primer*, and a commentary was appended at the end, written apparently by Ruth Berlau, whose quality can be gathered from its suggestion that Rommel's reinforcement of Mussolini's North African army in 1941 was designed to extend the Italian colonial empire.

Among Brecht's closest disciples in the GDR was the poet Günter Kunert, who was barely twenty years old when the Brechts came to settle there. He has described how he went to see Brecht – it must have been well after the demonstrations following Stalin's death in 1953 – in his Chausseestrasse flat, when Brecht suddenly turned to a cupboard with shallow drawers for maps and prints, and took out a closed folder containing large black sheets of card, each with a news picture cut from the press, and a quatrain beneath it. 'What do you think, Kunert: can this sort of thing be published?'

That was his question, and having looked through the pages I replied with a fairly enthusiastic 'yes'. As to 'how?' we discussed for some time, and I undertook to recommend it to the publishers of the *Eulenspiegel*. I would be responsible for the translation of the English-language captions and draft some sort of 'historical pointers'.

This must have been in 1954, after Brecht's cultural-political difficulties in the GDR had begun to disperse, following his sincere enough (but shrewdly timed) declaration of loyalty on 17 June 1953. Thus not only was the Berliner Ensemble at last allotted its own theatre but the whole cultural administration was overhauled, with the well-established Communist poet Johannes R. Becher becoming the minister and Brecht one of his advisers, as well as being elevated to vice president of the Academy of the Arts. Kunert, who was then with the *Eulenspiegel*, an officially humorous magazine, persuaded his colleagues there to make a contract with Brecht on 1 September 1954, the day the folder was handed in. Their first report was favourable: there were one or two minor changes to make, but in their view the book's approach was not merely documentary —

Bert Brecht is already indicating the dangers that have come about as a result of the imperialist victors of the West speculating on a new war – one for which they already secured starting-points in the course of World War II.

By 16 October it had been put on the firm's publishing programme for the remainder of that year. Then Kunert, as one of the editorial readers, suggested getting recommendations from Becher and the critic Johanna Rudolph, and advised some changes. An unsigned letter mentioned a new photo-epigram with the slogan 'Heil IG Farben' to follow no. 6, as well as an amended D-day quatrain (no. 63), and a deletion of the crude word for 'parts' in the Jane Wyman quatrain (no. 47). Brecht apparently had accepted these, though he rejected another proposed cut, saying bluntly that 'the author's opinion does not have to be the government's'.

Then the former 'Cultural Advisers' stepped in, in their new guise as 'Amt für Literatur', the Office for Literature. These people had learned of the book's rejection some five years earlier, and the premier's horror when he read it; moreover, it had been described as 'a collection of cuttings from English newspapers', amounting to 'the purest pacifism'. So they demanded that it be resubmitted to them. This happened in December, just as it was announced that Brecht was to be given the Stalin Peace Prize by the Russians – an impeccable accolade. In their congratulatory telegram, the *Eulenspiegel* editors told him that they had now got the long-awaited permission to print his book. To which the poet replied, thanking them and saying that he had just informed the Office for Literature that, as a member of the Academy of Arts, he had the right to give that permission himself. A month passed, and he asked the Office for a written explanation of their continued retention of the material. It is not known if they replied, but the printing arrangements were mysteriously delayed, and as late as the end of August 1955 there was a confidential meeting of Office members, where it was decided that 'this title could not make any positive contribution to our literature, and should really not be allowed to appear'. The only practical suggestion was that the distribution of the greater part of the edition might be held up. A last appeal to Brecht's finer feelings was made in September, but in the end, four days before Christmas and just a year since he had asserted his rights, the opposition caved in. The first edition of ten thousand was already out and slowly selling.

This whole story says a good deal about the seesaw problems of a great European poet in the 1940s and '50s, and it is amazing that it should end so well. However strange it may seem to the sheltered outsider, it is evidence not only of Brecht's willingness to stick out his neck in politically sensitive situations but also of his obstinacy in refusing to bow to any management that he could not respect. In 1956, the year of his death, his collaborator Hanns Eisler set thirteen of the epigrams (along with one from the putative 'Peace Primer') for soloists, men's chorus and an orchestra of brass, woodwind, two double basses and percussion under the title *Bilder aus der Kriegsfibel* (Pictures from the War Primer). It is a masterly work, a uniquely epigrammatic use of music, and a convincing

introduction to Brecht's photo-epigrams (as he termed them).* But how had the work suffered under the interventions and amendments of a long chain of advisers, arbiters and editors? Today one can get at least some idea of the changes made from 1940 on, along with any ensuing effects on the thrust of the whole book (see the Notes, pp. 100–103). Brecht himself was always able to make some debatable judgements, and also to change his own mind. This last was an ability he was positively proud of as a practitioner of 'dialectics'.

We can now see how right Brecht was to insist that the book came to a halt with the end of the Second World War and must accordingly be seen as a reaction to its time. Since then, the Cold War, which dominated the minds of his East German critics, has ended too, allowing the attitudes of Communists and their opponents to be dispassionately judged. We can see what they were getting at – however short-sightedly – when they argued that certain quatrains were no longer valid in the mid-fifties. It is true that most of those who would read the book in the GDR had been supporting the Nazis and their generals a decade earlier, and the suggestion by Brecht's would-be mentors that some citizens might want to cut out the portraits of their old leaders and use them as pinups was not so silly as it now sounds. Their persuasion of him to replace Friedrich Ebert, the first Social Democrat president of the Weimar Republic, with Gustav Noske is perhaps even more understandable, given that the new SED wished to appeal to former Social Democrats who had opposed the Nazis. Outstanding among these were Premier Grotewohl, who had so sharply rejected the book in 1950, and the mayor of East Berlin, who was President Ebert's son.

Elements of the postwar antagonism between Russia and the West had already been in the wartime air: see, for instance, the note on Brecht's changing of his D-day quatrain (no. 63) in 1954 so as to strengthen this by its new reference to 'the men of Stalingrad'. The inclusion of Hitler's closest associates (nos 30–33) came *after* the original twenty-odd pages; an IG Farben epigram (added in tacit response to Stefan Heymann's criticisms above) was in line with the postwar War Crime trials, though eventually it was omitted from the book, ostensibly for lacking an adequate illustration. Clearly Brecht was moved by the bombing of England in 1940, yet he later set aside the Churchill page of that year (no. 15), when Britain stood alone against the German forces, in order to use it in a more 'imperialist' context following the portrayal of Africa as a beautiful victim (no. 44). The first actual mention of a British war effort is in the original German editorial notes on North Africa (nos 42 and 43); these attributed the Sicilian and Italian landings to American forces alone (no. 59), and the original caption to the picture of the Normandy landings (no. 63) mentions only US forces. Yet despite this doctoring of history, and for whatever reason it was done, the compressed power of the poems is barely affected.

The final order of the *Eulenspiegel* edition is a bit confusing, with Brecht's afterthoughts and the later editors supplementing his original selection with previously unpublished photo-epigrams, irrespective of chronology, after the final image. We have therefore made a few minor changes in the order of the quatrains, absorbing some of the supplementary items where they seem to fit. Thus we have put Ebert back where he originally belonged (no. 29), relegating the pathetic Noske to the end. Noske, known for his remark that 'somebody has to be the bloodhound', was the Social Democrat minister of the interior who used the Reichswehr and its irregular aides in Berlin to suppress the Spartacist Revolt of 1919. Ebert was the first president of the Republic, from that year till his death in 1925. He, not Noske, was the man who Brecht initially included as paving the way for the nationalist reaction and the rise of the Nazis.

* Eisler's cantata was composed in 1957, after Brecht's death, using fifteen of the epigrams and projections of the corresponding photographs. It consists of an introduction (no. 71), i (no. 4), ii (no. 18), iii (no. 21), iv (no. 25), v (no. 34), vi (no. 37), vii (no. 54), viii (no. 56), ix (no. 39), x (no. 41), xi (no. 73), xii (no. 75), xiii (no. 79), and xiv (no. 85). The music too is epigrammatic, and the whole work takes just over ten minutes.

In preparing the first English-language edition of Brecht's *War Primer* we have depended all along on the detailed criticisms and suggestions of Naomi Replansky, who recalls arriving in Santa Monica, California, when Brecht was working there with Charles Laughton on the English translation of *Galileo*. That was in 1946 and, by her own account in *The Brecht Yearbook, No. 20* (Madison, WI, 1995), she already felt 'an affinity of influence' thanks to her interest in Shakespeare, Villon, translations from the Chinese and Japanese (notably Arthur Waley's) and the Loeb bilingual edition of the *Greek Anthology*, along with English-language 'songs and ballads; spirituals and blues'. Brecht, she found,

> read English subtly and well... We would go through the original word by word, making sure I got the exact meaning. We digressed; Brecht walked up and down the narrow workroom, gesturing with his cigar, open to criticism and disputation.
>
> I would then take the original home and try (often obsessively) to carry over its poetic strength into English and to keep at least two of the rhymes.

Many of Brecht's epigrams 'had a concentrated power', and she translated those that appealed to her. At the same time, she was moved to use the same form herself, as in her 'Epitaph: 1945':

> My spoon was lifted when the bomb came down
> That left no face, no hand, no spoon to hold.
> One hundred thousand died in my hometown.
> This came to pass before my soup was cold.

We are lucky to have had her patient and self-effacing collaboration.

For material in this afterword and the notes (pp. 100–103), we are much indebted to the German poet Günter Kunert, who was largely responsible for the original *Eulenspiegel* publication a decade after the fall of the Third Reich. Some of his 'late thoughts' about his friend Brecht can be found in the same *Brecht Yearbook*, and we owe to him a firsthand insight into the problems of producing a book that was so hard to reconcile with the Stalinist doctrine of Socialist Realism. Documentary evidence of the difficulties put in its way by the politicians has also been generously supplied by the Bertolt-Brecht Archiv in Berlin under its director Erdmut Wizisla, who has helped and encouraged us throughout. Thanks are also due to Gunn Brinson who located the original use of many of the photographs in Scandinavian and US newspapers and magazines. We must now hope that these and other supporters of this relatively little-known Brecht work will be happy at the result of its introduction to the English-speaking world. One hundred years since the poet's birth; half a century since the end of our war.

BRECHT'S WAR: A CHRONOLOGY

Prelude

The Brechts had been living as exiles in Denmark since the end of 1933, the year that Hitler came to power in Germany. In 1935, the Nuremberg Race Laws marked the beginning of official anti-Semitism in Hitler's newly instituted Third Reich. (Brecht was not Jewish, but his wife Helene Weigel was.) The Communist International decided to join forces with the Socialists and any others prepared to resist German and Italian Fascism; the result was Popular Front governments in France and Spain. The Spanish Civil War started in summer 1936 as a revolt against the second of these by the Spanish army under General Franco. As links between Germany, Italy and the Spanish rebels became closer, with Japan as an anti-Communist ally, Stalin in Russia launched a massive purge of his Communist Party, during which a number of German exiles were banished to camps or killed.

By early 1937 Brecht had written most of his earlier (unrhymed, unillustrated) 'German War Primer' poems, which were included in his book *Svendborg Poems* the following year, along with the 'German Satires', the literary sonnets and such longer items as 'Spring 1938', the Lao-tse poem and 'To Those Born Later'.

In 1938 Hitler annexed Austria and the German-speaking areas of Czechoslovakia. The rest of that country fell to him in spring 1939. Europe, including Britain, began last-minute preparations for war.

The Brechts had two children in exile with them, a son in his teens and a daughter not quite ten. The household included his Berlin secretary and assistant, Margarete Steffin, and on leaving Scandinavia was joined by his Danish mistress Ruth Berlau.

The War Years

1939 Photograph nos 4, 31

23 April	*The Brechts leave Denmark for Sweden.*
28 May	The fall of Madrid marks the defeat of the Spanish Republic, ending the Civil War.
23 August	Nazi-Soviet Pact signed in Moscow.
1–3 September	Germany invades Poland. Britain and France declare war. Start of the Second World War.
17 September	Russians invade Poland too. Partition of Poland follows.
by 27 September	*Brecht has started writing* Mother Courage.
5 to 11 November	*Following that, Brecht writes* The Trial of Lucullus *for radio.*
30 November	Russians invade Finland.

1940, first half Photograph nos 1, 5, 6, 15

12 March	Finnish-Russian peace settlement.
9 April	Germany invades Norway and Denmark.
mid-April	*Brechts move to Finland.*
May	*Brecht invited to teach at the New School for Social Research, New York.*
10 May	Germans launch blitzkrieg through the Low Countries into France. Churchill succeeds Chamberlain as Prime Minister.
29 May	British army starts evacuation via Dunkirk.
mid-June	Mussolini declares war. Germans take Paris. French surrender, form new rump state ruled by Pétain and Laval from Vichy.
by end of June	*Brecht completes* The Good Person of Szechwan.

1940, second half Photograph nos 2, 3, 7, 8, 10, 16–19, 21–23, 25, 28, 34, 36, 44, 56

	The Brechts stay till early October with Hella Wuolijoki at her country house.
9 July	RAF night bombing of Germany.
	Luftwaffe bombardment of Britain, climax of day raids in mid-August, followed by nighttime Blitz on London.
27 August	*Brecht hears that his old friend the author Lion Feuchtwanger has escaped from French internment via Portugal to the US.*
September	*Writing* Puntila *with Wuolijoki.*
December	British Eighth Army advances into Libya, reaching Benghazi by 6 February.

1941 Photograph nos 13, 24, 32, 51, 66

February	German forces under Erwin Rommel arrive in Libya.
10 March–12 April	*Brecht writing* The Resistible Rise of Arturo Ui.
9 April	Mother Courage *premiere in neutral Zurich.*
7 April	Rommel's Afrika Korps pushes British back to Tobruk.
15 May	*The Brechts leave Helsinki for Moscow, where they take the Trans-Siberian railway on 30 May, leaving Margarete Steffin in hospital.*
4 June	*Death of Steffin from TB.*
13 June	*The Brechts sail from Vladivostok on a Swedish ship, arriving in Los Angeles on 21 July.*

22 June	Germans invade USSR. Finland and Hungary join them.
27 July	Japanese land in Indochina.
by mid-October	Germans are sixty miles from Moscow and besieging Leningrad.
November	*Now settled in Santa Monica, Brecht writes 'The Children's Crusade'. At a 'Jewish club' Fritz Kortner gives reading of the earlier 'German War Primer' epigrams.*
7 December	Japan attacks Pearl Harbor, bringing the USA into the war.
November–December	Russians beat off attacks on Moscow.
25 December	Surrender of Hong Kong to the Japanese.

1942	Photograph nos 47, 69. Brecht includes 40, 46, 48 and 70 in his *Journals.*
January	*Brecht writes 'To the German Soldiers in the East'.*
12 February	Singapore surrenders to Japanese.
9 April	so does Bataan (in the Philippines).
20 April	*Hanns Eisler arrives from New York.*
May	*Ruth Berlau moves to New York to work for the Office of War Information.*
end of May–mid-December	*Brecht working on Fritz Lang's film* Hangmen Also Die *about the assassination of Reinhard Heydrich in Prague.*
1 June	Heavy bombing of Cologne initiates RAF raids on German towns.
end of October	Americans land in Algeria. Eighth Army's defeat of Rommel at El Alamein leads to his withdrawal from Libya by February.
November	*Brecht and Feuchtwanger start work on* The Visions of Simone Machard.
19 November	German defeat at Stalingrad leads to General Paulus's surrender in January.

1943	Photograph nos 37, 49, 50, 52–55, 57–59, 71, 72, 80
4 February	Good Person of Szechwan *premiere in Zurich.*
12 February	*Brecht joins Berlau in New York for three months.*
6 March	*'Brecht evening' at Piscator's New School theatre starts Brecht's collaboration with a new composer, Paul Dessau.*
29 March	Eighth Army bypasses Mareth Line (in Southern Tunisia) and advances into Tunisia.
20 April	Warsaw ghetto massacre.
24 April	*Brecht evening at Heckscher Theatre on East 104th Street, New York, with reading of epigrams and projections from his* Contemporary Picture Book.
12 May	German army in Tunisia surrenders.
26 May	*Brecht back in Santa Monica; writes* Schweik in the Second World War.
26 June	Hamburg largely destroyed by bombing.
29 June	US lands in New Guinea.
10 July	British and Americans land in Sicily. A fortnight later Mussolini falls.
3 September	Allies invade Italy, whose government surrenders. Naples is taken on the 30th.
9 September	Galileo *(first version) premiere in Zurich.*
19 November	*Brecht rejoins Berlau in New York for four months.*
5 December	*He writes to Auden proposing collaboration on Webster's* The Duchess of Malfi *on whose adaptation and translation he has been working with H. R. Hays.*

1944	Photograph nos 50–64, 74, 78

	Epigrams ascribed to this year comprise those which Brecht wrote to accompany most of the photos so far listed, plus 9, 11, 12, 14, 26, 30, 38, 39, 42, 43, 60, 62, 65, 67, 68, 73, 75, 80, and 81 for which dates of the photographs are more uncertain.
20 January	2,000-ton bomb raid on Berlin.
February–June	*First publication of three epigrams (nos 70, 71 and 78) in the* Austro American Tribune *(New York).*
mid-March	*Brecht returns to Santa Monica and starts work on* The Caucasian Chalk Circle. *First version finished by 5 June.*
4 June	Fall of Rome.
6 June	D–day. Allied landings in Lower Normandy.
20 June	*Brecht has started adding to the epigrams. There are now sixty of them.*
end of July	*Dessau in Santa Monica setting some of the epigrams as part of his* German Miserere.
20 July	Count Stauffenberg tries to blow up Hitler. The Russians enter Poland and take Brest-Litovsk (28th). Warsaw Rising (1 August) is not supported by the Russians.
25 August	Allies recapture Paris.
1 September	*Brecht completes revision of* Caucasian Chalk Circle.
early September	*Birth and death of Brecht's son with Ruth Berlau, who remains in Los Angeles till the following spring.*
24 November	Allies take Strasbourg.
December	*Berlau has been studying photography and now makes archive photos of Brecht's poems, including the* War Primer. *Brecht starts work with Charles Laughton on translation and adaptation of* Galileo.

1945	Photograph nos 33, 43, 56, 58

3 January	With the defeat of the German counteroffensive in the Ardennes (Battle of the Bulge) the war in the West is nearly over.
20 January	*Dessau plays Brecht some of his epigram settings over the phone.*
12 April	Death of Roosevelt.
30 April	Hitler's suicide in Berlin.
8 May	Surrender of the German armed forces.
22 May	*Brecht to New York, joins Berlau. Unsuccessful production there of* Private Life of the Master Race *(adapted from his* Fear and Misery of the Third Reich*).*
18 July	*Return to Santa Monica and work with Laughton.*
6 August	The first atom bomb destroys Hiroshima.
14 August	Japan surrenders. End of the Second World War.

Aftermath

At the end of 1945 Ruth Berlau had a bad breakdown in New York, and was taken to Amityville hospital for electric shock treatment. By that time the work with Laughton on *Galileo* was finished, and he and Brecht were pursuing various possibilities of production. Influenza prevented Brecht from getting to New York before February, but then in March Berlau was released into his care, and he brought her back to Santa Monica in May. For the next year and a half, in addition to planning his return to Germany, he was concerned mainly with the American productions of *The Duchess of Malfi* (September–October 1946) and *Galileo* (May–July 1947), not to mention the beginnings of the Truman administration's anti-Communist witch hunt via the FBI and the House Un-American Activities Committee. Before he left for Europe at the end of October 1947, Brecht deposited microfilm copies of a number of his works, published and unpublished, in the New York Public Library.

War Primer was now in effect finished and would be ready for submission to publishers as soon as Brecht, with Berlau as agent for it, had found his footing back in a German-speaking country. This was at first Switzerland, then, from 1949 on, in the Soviet-controlled portion of Germany itself. The war was over. Like the soldiers in no. 71, it had gone cold.

NOTES

In the notes below, dates of poems (as for no. 1 below) are Brecht's own as marked on his scripts. Dates of attribution are from the editorial notes in Volume 12 of Bertolt Brecht, *Werke*, edited by Werner Hecht, Jan Knopf, Werner Mittenzwei and Klaus-Detlef Müller (Berlin and Frankfurt, 1988). The epigrams fall into roughly four groups: the first two dozen or so assembled before leaving Europe in spring 1941; a handful added over the next two years; then another thirty in America from 1943–44; finally the half dozen or so additions before Brecht left the United States. Many are ascribed to 1944, when Brecht first put most of this material together, but sometimes the photos date from earlier, so that the basic idea of the poems may already have been there, perhaps even in a draft version.

A number of the epigrams from the 'Anhang' (or Addendum) of the 1994 German edition have been shifted to what seem to be their logical or chronological places; two others seem repetitious or otherwise unassimilable.

1. Adolf Hitler. Poem dated 14.3.40. The words recall Hitler's speech on 15 March 1936: 'I take the path that fate dictates with the assurance of a sleepwalker.'
2. Photo from *Life*, 30 December 1940. Caption appears to relate to the US steel industry. Poem attributed to 1944.
3. Poem dated 9.10.40. Brecht was making notes on the English-language German magazine *Signals*. He attributed the picture to 1936, first year of the Spanish Civil War.
4. Photo from *Life*, 20 February 1939. Caption gives the subject as the Spanish Nationalist General Yagüe attending an open-air mass to mark Franco's capture of Barcelona at the end of the Civil War. Poem attributed to 1944.
5. Photo from a Swedish magazine, June 1940. Poem attributed to that same year. The German invasion of Poland, cited in the original German edition, took place in the previous September. Brecht first used the poem as part of his 'Memorial Tablets for Those Fallen in Hitler's War Against France', written in June/July 1940.
6. Poem dated 3.5.40. Photo from a Swedish magazine, June 1940. The German invasion of Norway and Denmark began on 9 April; the British troops pulled out on 2 May.
7. Poem written in 1940. Photo from an unidentified Swedish magazine. Skagerrak and Kattegat are the seas off northern Denmark. German losses in the Norway operation were given as 5,300.

8. Photo from *Life*, 30.12.40. The German army reached the Albert Canal between Antwerp and Liège a few days after invading Holland and Belgium on 10 May.

9. A related cutting is dated 17 July, following the French armistice. Roubaix is on the frontier with Belgium. Poem attributed to 1944.

10. Photo from an unidentified American magazine of late 1940. Poem first used as part of 'Memorial Tablets' together with no. 5 above. The 'unknown' victim here is clearly German.

11. Photo by 'Weltbild', Berlin, showing the Seine in Paris. Caption in Swedish. Poem attributed to 1944.

12. Photo from an unidentified American paper. Poem attributed to 1944.

13. Photo from *Life* of unknown date. A differently trimmed and captioned version is in Brecht's *Journals*, 22 July 1941. The subject is his old friend and California neighbour, the novelist Lion Feuchtwanger, who (as noted in Brecht's *Journals* for 27 August 1940) escaped via Portugal after French internment. Poem attributed to 1944.

14. Photo of unknown origin, showing Pétain and Laval, leaders of the right-wing Vichy government recognised by the victorious Germans. Poem attributed to 1944.

15. Poem dated 20.5.40. Photo of Winston Churchill from unidentified Swedish magazine of June 1940.

16. Poem dated 26.9.40, during the Luftwaffe's Blitz on London and other British cities.

17. Photo from unidentified Swedish paper. The 'course that differed': i.e. not the one awaited by the pre-war Right, which they had expected to be against the Soviet Union. Poem attributed to 1940.

18. Poem dated 2.10.40. Photo from an unidentified Swedish paper shows Liverpool docks, centring on the Liver Building (black, with twin towers).

19. Poem dated 4.8.40. Photo reputedly from an unidentified Swedish paper of 20 January 1942 (by which time Brecht was in the US). Brecht's collage resembles those in the *Journals*, where he noted on 10 August 1940 that 'the ring of steel is closing round britain. the aeroplane, the new weapon, is showing itself to be more terribly new than when it was employed in the last war.' He was then in Finland.

20. Poem dated 6.11.40. Photo of observer in a day bomber, from an unidentified German publication.

21. Poem dated 23.11.40. Photo of unknown origin shows Aldwych Station on the London Underground, in use as an air-raid shelter during the Blitz.

22. Poem dated 3.12.40. Photo from an unidentified Swedish paper.

23. Poem dated 6.11.40. Air photo of unknown origin shows effect of bombing of oil installations; cf. Brecht's *Journals* for 21 September 1940. Picture from *Berliner Illustrirte* of 19 September, under the heading 'Deutsche Baumeister' (German Master Builders).

24. Poem dated 4.3.41. Photo from an unidentified Swedish paper of January 1941, showing the Thames in London with Tower Bridge. Like no. 19 this resembles a collage from the *Journals*.

25. Poem dated 24.12.40. Photo from an unidentified Swedish magazine of October 1940.

26. Poem dated 15.10.40. This and no. 27 face one another in the *Journals* for that day.

27. Poem dated 15.10.40.

28. Poem dated 12.12.40. Photo from an unidentified Swedish magazine, later used in *Life* of 23 December 1940. Hitler is shown speaking at the Rheinmetall-Börsig factory in Berlin on 10 December.

29. Friedrich Ebert. This image and quatrain were replaced by no. 82 (Gustav Noske) in the German edition (see Afterword, p. 93).

30. Photo from unknown source. Poem attributed to 1944.

31. Photo from *Life*, 20 March 1939. Goebbels, Hitler's Minister of Propaganda, who had a club foot, was a Doctor of Philosophy. Poem attributed to 1944.

32. Photo from *Life*, 3 February 1941. Goebbels (left) was Josef, Goering Hermann. Poem attributed to 1944.

33. Photo from *Life*, 12 February 1945, originally taken in February 1938 at an 'International Auto Meeting', here captioned so as to situate the three Nazi leaders at the Bayreuth Opera, home of Richard Wagner. Poem attributed to 1944. Its references are (in line 1) twice to *Lohengrin*, then (in line 2) to *Tannhäuser* and *Walkyrie*, and finally (line 3) to *Rheingold*.

34. Poem dated 2.12.40. Photo of unknown origin.

35. Cutting from an unidentified Swedish paper carrying a news item datelined Berlin from the German agency DNB. Poem attributed to 1944.

36. Poem dated 12 December 1940. From an unidentified American paper. Described by the German editors as an 'industrial plant in Katowice' in Polish Silesia. Kirkenaes was a German airbase in north Norway.

37. Photo from *Life*, 16 August 1943, showing a sand-table model of the battlefield of that summer where the Red Army made crucial advances. Poem attributed to 1944.

38. Photo of unknown origin. Poem attributed to 1944. North Cape is the northernmost point of Norway, well within the Arctic Circle.

39. Photo from unidentified source, titled by the German editors 'Soviet Partisans'. Poem attributed to 1944.

40. Photos from *Life*, 12 October 1942. Clockwise from top left: von Bock, Sperrle, von Rundstedt, List, Guderian, Rommel: all Field Marshals but for Guderian (General). Sperrle was Luftwaffe, the rest Army. Poem attributed to 1944.

41. Poem attributed to 4 June 1940, when the accompanying photo showed French helmets. Amended version 1954, after which the present photo was taken of German helmets from the Berliner Ensemble's wardrobe.

42. Photo from *Life* of unknown date. Left: Rommel, whose Afrika Korps landed in Libya in March 1941, advanced to within Egypt and was pushed back at the Battle of Alamein in October 1942. Poem attributed to 1944.

43. Photo from same page of *Life* as no. 42. Poem attributed to 1944.

44. Poem dated 15.12.40. Photo of unknown origin.

45. Poem dated 8.10.41. Photo from *Life* of unknown date.

46. Photo from *Life*, 2 March 1942, presumably from the same set as the four photographs included in the *Journals* for 25 February 1942 with Brecht's note: 'congress voted to give itself a pension, a movement was started to collect gift parcels for starving congressmen.' One of these is shown to consist of onions, with a label saying 'Let's all CRY!'. Spokane is in Washington State. Poem attributed to 1944.

47. Poem attributed to 1944. Photo from *Life*, 19 January 1942, shows the film actress Jane Wyman in an 'RAF blue' dress.

48. Photo in *Life*, 23 March 1942, without its heading, gummed in Brecht's *Journal* for 5 April, with printed caption 'After the Bombing (Singapore)'. Singapore had surrendered to the Japanese on 15 March. Poem attributed to 1944.

49. Photo from *Life*, 15 February 1943. Poem attributed to 1944.

50. Photo from *Life*, 25 October 1943, whose editor had appealed to its readers for photos that would cheer up the US troops in the Pacific. Poem attributed to 1944.

51. Photo from *Life*, 17 March 1941. Poem attributed to 1944.

52. Photo from *Life*, 8 March 1943. Poem attributed to 1944.

53. Photo from *Life*, 1 February 1943. 'Domei' was the name of the official Japanese press agency. Poem attributed to 1944.

54. Photo from *Life*, 15 February 1943. Poem attributed to 1944.

55. Photo from *Life*. Poem attributed to 1944.

56. German photos from an unidentified Swedish paper, 1940. Poem attributed to 1944.

57. Photo from *Life*, 15 February 1943. Poem attributed to 1944.

58. Photo from *Life*. Poem attributed to 1944.

59. Photo from *Life*, 30 August 1943. Poem attributed to 1944.

60. Photo from an unidentified American journal, showing how 'American Military Government officers sell American flour to Italian civilians'. After the Italian surrender on 3 September, Churchill was anxious to preserve the monarchy against the wishes of the Resistance. Poem attributed to 1944.

61. Photo from *Life*, 7 February 1944. Poem attributed to 1944.

62. Photo from *Life*, 29 May 1944. A page of pictures of exhausted American soldiers, taken presumably during the Allied assault in Italy that led to the fall of Rome. Poem attributed to 1944.

63. Photo from *Life*, 19 June 1944, taken during the Allied landings in Normandy. Poem attributed to 1944, revised in 1954. The last three lines of the earlier version read: 'The man from distant Essen on the Ruhr saw the man from distant Maine rising from the sea at daybreak, and didn't understand.'

64. Poem attributed to 1944. Berlin agency photo marked as showing Churchill with Montgomery on

the occasion of his second visit to the front following D–day. An umbrella had been the companion of Churchill's precursor Neville Chamberlain, who stood for the appeasement of Hitler.

65. Photos of a German (left) and Russian (right) soldier, respectively from the Associated Press and the *New York Times*. Organ of publication unknown. Poem attributed to 1944.

66. Photo from *Life*, 27 October 1941. Caption by the editors of the German edition. Poem attributed to 1944.

67. Poem attributed to 1944. The battle of the Orel salient was in July 1943. Photo from an unknown German source.

68. Photo from unidentified American paper. Swing and Davis: the commentator Raymond Gram Swing and Joseph Davis, the US Ambassador in Moscow. Poem attributed to 1944.

69. Photo was 'picture of the week' in *Life*, 4 May 1942. According to the long caption it shows two parents identifying the dead body of their son at Kerch in the Crimea, where the German Commandant had ordered over 7,000 civilians to be shot before the Red Army recaptured it that February. Poem attributed to 1944.

70. Poem published in the *Austro-American Tribune*, New York, February 1944. Photo from an unidentified American paper, January 1942, gummed in *Journals* for 5 June with caption: 'A Russian family comes back home. The Germans had been there and had left – under fire.'

71. Poem published in the *Austro-American Tribune*, March 1944. Photo from *Life*, 22 February 1943.

72. Photo from *Life*, 22 February 1943. Poem attributed to 1944.

73. Photos from an unidentified American paper (possibly *Life*). Poem attributed to 1944.

74. Photo from the *Saturday Evening Post*, October 1944. The soldiers are German. Poem attributed to 1944.

75. Photo from an unidentified American paper. Poem attributed to 1944.

76. Photo from the *New York Times Magazine*, 15 April 1945. Poem attributed to 1945.

77. Photo from *Life* of unknown date shows Ernest Bevin, Churchill's anti-Communist Minister of Labour, who became foreign minister in 1945. Poem attributed to 1944.

78. Published in the *Austro-American Tribune*, June 1944. Photo *Life*, 5 July 1943. There is a caption which says this shows US soldiers rescuing a young Black from a racist mob in downtown Detroit. Kiska (an Aleutian island), Bataan (in the Philippines) and the Ardennes were all recent battles. Poem attributed to 1944.

79. Photo from *Life*, 26 March 1945. Included by Brecht in a letter of that time to Ruth Berlau. Poem attributed to 1945.

80. *Life*, 14 June 1943. Poem attributed to 1944.

81. Photo from an unidentified American periodical. 20 April was Hitler's birthday. He killed himself on 30 April 1945. Poem, attributed to 1944, is almost identical with the last four lines of the epilogue to Brecht's play *The Resistible Rise of Arturo Ui*.

82. Poem supposedly written in late 1946, when the picture was published in Berlin on the occasion of Gustav Noske's death. Interior Minister of the Social Democrat–led Republican government charged with directing the suppression of the Spartacist revolt in 1919, Noske had turned to the right-wing Free Corps, precursors of the Nazis. In 1939 Hitler arrested him on suspicion of resistance contacts, but the case was never proved.

83. From unidentified US paper.

84. Poem dated 1950. The collage is included in the *Journals* for 10 June 1950, following Brecht's return to East Berlin. The helmet bears the name 'WOLF'.

85. Photo from unidentified East German archive. This epigram also constitutes the third stanza of Brecht's poem (*c.* 1955) 'To the Students of the Workers' and Peasants' Faculty'; a note in the one-volume edition of Brecht's poetry (Frankfurt, 1981) ascribes it to the projected 'Peace Primer' (cf. no. 84).

CONCORDANCE

The sequence of photo-epigrams in this edition differs from that in the German edition (see Afterword, p. 93). This concordance shows which numbers in the second (1994) German edition correspond to which photo-epigrams in this edition. Numbers 1 through 14 are in the same order and position.

This edition	German 1994 edition	This edition	German 1994 edition
15	38	53	44
16	15	54	45
17	16	55	46
18	17	56	72
19	82	57	47
20	18	58	48
21	19	59	49
22	20	60	50
23	21	61	51
24	86	62	52
25	22	63	53
26	83	64	80
27	84	65	55
28	23	66	56
29	70	67	58
30	71	68	74
31	26	69	59
32	27	70	60
33	28	71	61
34	29	72	62
35	31	73	63
36	32	74	64
37	33	75	65
38	34	76	66
39	54	77	75
40	30	78	78
41	57	79	67
42	35	80	68
43	36	81	69
44	37	82	24
45	85	83	87
46	79	84	88
47	77	85	*back of jacket*
48	39		
49	40		
50	41		
51	42		
52	43		

Nos 25, 73, 76 and 81 in the German edition involve alternative photographs to epigrams 15, 30 and 41 in this edition.

Printed in the United States
by Baker & Taylor Publisher Services